IMAGES
of America

BOYNTON BEACH

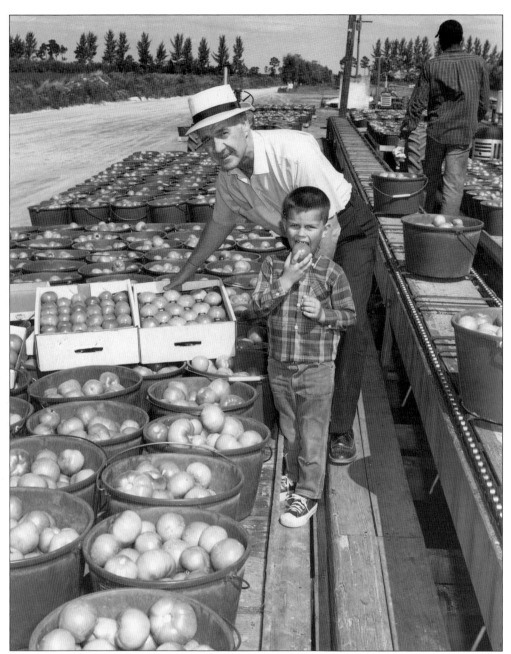

FARM FRESH TOMATOES, 1968. A young boy sinks his teeth into a juicy tomato during the harvest on Flavor Pict Road in western Boynton Beach at the pinnacle of the farming industry. (Courtesy of Boynton Beach City Library.)

On the Cover:
A WINNING SAILFISH, 1950s. An elated Jean Pipes proudly holds a sailfish that she caught on Capt. Homer Adams's boat during the Boynton Beach Fishing Tournament. (Courtesy of Mrs. Shirley Adams.)

IMAGES
of America

BOYNTON BEACH

M. Randall Gill
in conjunction with
the Boynton Beach City Library

Published by Arcadia Publishing
Charleston SC, Chicago IL, Portsmouth NH, San Francisco CA

Printed in the United States of America

Library of Congress Catalog Card Number: 2005922739

For all general information contact Arcadia Publishing at:
Telephone 843-853-2070
Fax 843-853-0044
E-mail sales@arcadiapublishing.com
For customer service and orders:
Toll-Free 1-888-313-2665

Visit us on the internet at http://www.arcadiapublishing.com

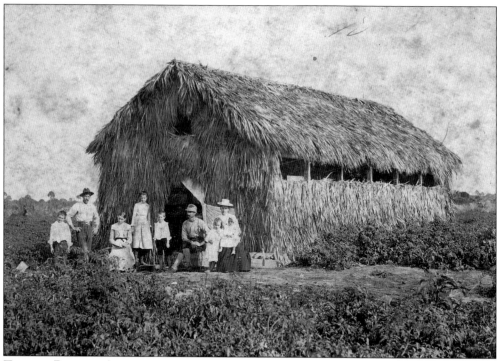

TOMATO PACKING SHED, C. 1901. Horace Bentley Murray, of Michigan, and his family were among the first families to settle in Boynton, arriving in January 1896. When they first arrived, they pitched tents until their home was built. There were two African American families farming the muck land near the present-day U.S. Highway 1 and Boynton Beach Boulevard. The S. B. Cade and L. A. King families helped the new settlers learn about farming in South Florida. The tomato packing shed shown here was located just south of where the Banana Boat restaurant is today. Some historians believe the family lived in the palm-thatched structure until their permanent home was built. (Courtesy of Boynton Beach Historical Society.)

CONTENTS

Acknowledgments 6

Introduction 7

1. A Tropical Frontier Called Boynton: Pioneers 9

2. Henry Flagler's Railroad to Paradise: Trains 21

3. Hooked in the Mouth of the Gulf Stream: Fishing 29

4. Sun and Fun: The Beach 45

5. Look at the Crops as You Pass: Farming 53

6. The School Bell is Ringing: Education 63

7. Everyone Loves a Parade: Celebrations 77

8. Let The Games Begin: Sports And Recreation 85

9. Gateway to the Gulf Stream: Civic And Social 93

ACKNOWLEDGMENTS

This book of photographs depicting the progression and history of Boynton Beach would not be possible without the assistance of many people. Janet De Vries, archivist and library associate, co-authored this book on behalf of the Boynton Beach City Library. Digging like archaeologists, we carefully combed through packets, boxes, and brittle scrapbooks. We would shout "gold" when we found a striking old photograph hidden away in a box, photograph album, or yellowed envelope. Janet's knowledge and enthusiasm for history made the long weeks of research go quickly. Thanks to Virginia K. Farace, director of the Boynton Beach City Library. For over 35 years, Virginia has served as an anchor in the changing tides of Boynton Beach. Her insight and fortitude for preserving history resulted in a collection of images we are proud to make available to readers of all ages. Arleen Dennison, head of Library Special Services, and executive director of the Boynton Cultural Centre and Schoolhouse Children's Museum, has united a growing number of community members, pioneer families, and school alumni in sharing their historic memories and photograph collections. For nearly 40 years, the members of the Boynton Beach Historical Society have amassed an archive of recollections, photographs, documents, and artifacts chronicling Boynton Beach's rich history. The Greater Boynton Beach Chamber of Commerce and various departments in the city have also shared images and information.

We thank all those individuals who captured memories frozen in time for future generations to enjoy and learn about themselves and their community. This Images of America book would not be successful without the help of many old and new friends. To any helper who sent material, called, or denoted facts, we are deeply grateful.

Special thanks to editor Barbie Langston Halaby for her belief in this book and for her encouragement. In a variety of ways, other friends came forward with assistance that significantly enhanced the quality of this project. We could not have had so many poignant vintage photographs without the past donors who gave images to the library and historical societies. Hopefully this effort will motivate others to bring their photographs to the archives for future generations to admire. To the many others who helped to shape and bring this book to life we are particularly thankful: Sara Ackermann, Cecil Adderley, Lois Weaver Argo, Leo Birdie, Geoffrey Botnik, Janet Davis, Joan and Robert DuBois, Madeleine Ehrhardt, Susan Gillis of the Boca Raton Historical Society, Blanche Girtman, Lynn Grace, Penni Greenly, Lori Jenkins, Jack Kujala, Debbie and Wally Majors, Bob McClory, Ethel McGhee, Helen Meisenheimer, Debi Murray and Tony Marconi of the Historical Society of Palm Beach County, Esther Orr, Harvey Oyer Jr., Dorothy Patterson of the Delray Beach Historical Society, Barbara Poleo and Rodney Dillon of Past Perfect Florida History Bookstore, Jim and Leah Pisarski, Jimmy Pollock, Lena Rahming, Paul and Joan Redmond, Judith Sanders, Gregg Seider for his photographic assistance, Mary Shook, Susan Sinclair, Elise Shankle, Stan Sheets, Voncile Smith, Grady Stearns, Gertrude Sullivan, Robert and Sheila Taylor, Lorraine Vicki, C. Stanley Weaver, and Curtis and Nain Weaver, Marion and Cecile Weems, Katie White, the staff of Boynton Beach City Library, and the staff of Schoolhouse Children's Museum.

A warm thank you to our families for their support of this project and their abiding love. We realize you were unselfish and patient as we missed family events during the course of this book's planning and implementation. To you and all the pioneers, we dedicate this book.

INTRODUCTION

In the year 1894, Maj. Nathan S. Boynton and Congressman William S. Linton, businessmen from Michigan, traveled the canal south from Palm Beach in a boat named the *Victor*. This small motorized launch was captained by Frederick C. Voss, a settler in the Hypoluxo area. These two men would prophetically become victorious in establishing neighboring communities in South Florida. Their boat steadily moved through the long body of water known as Lake Worth. This was the only way to reach the primitive frontier to the south. Blue herons and snowy white egrets swooped overhead as alligators gazed at the newcomers. For hours, the men could hear the crashing of the turquoise ocean waves to the east. To the west, they could smell the piney scrub flatlands.

State historians believe the first humans migrated to Florida from Southern Georgia about 10,000 BC. Pottery shards, charcoal, and other artifacts have been found in the Boynton Inlet area and western sections of Boynton. Native Americans who left these artifacts could have been members of the Tekesta, Calusa, or Aias tribes who lived about 500 BC. By the 18th century, the majority of Seminoles had migrated farther south and settled in the Fort Lauderdale region.

There is not any evidence of a Spanish explorer ever landing on this beach area. Explorer Ponce de Leon did sail by in his ship after his discovery of Florida in 1513. The swift, warm current of the Gulf Stream, just a few miles offshore from Boynton, would be an asset to the Spanish treasure ships returning to Spain. Many of the ships, however, never made it home, sunken by treacherous coral reefs, deadly hurricanes, and marauding pirates.

According to early pioneer Charles W. Pierce, in the 1870s, the southeast coast of Florida was "still a howling wilderness." In 1875, Capt. James A. Armour, the head lighthouse keeper at the Jupiter Lighthouse, acquired the future Boynton property from the United States government and built a small palmetto-thatched home. In 1877, a young man from Michigan, Dexter Hubel, located his homestead claim on the ocean ridge directly east of the present downtown area of Boynton Beach. Other settlers joined Hubel and had to scavenge the beach for necessities that would wash up from ships wrecked in a storm. Floating lumber would help them build sturdy homes. Sweet potatoes, swamp cabbage, and squirrel stew made a favorite meal during this time.

By the 1890s, when Maj. Nathan Boynton was heading to this area, changes were already occurring. Wild game had retreated west of the canal, and the population was starting to grow. The Florida East Coast Canal, now part of the Intracoastal Waterway, was dredged from Lake Worth south all the way to Delray by 1896. Henry Flagler's Florida East Coast Railroad was approaching, and settlers could hear the rhythmic chanting of workers laying rails off in the distance. When Major Boynton sailed into this tropical area in 1894, he stepped off his naphtha vessel onto the oozy muck bordering the canal. This distinguished Civil War veteran was immediately enthralled by the area and bought 400 acres of land, including a mile of ocean frontage. His friend, William Linton, would go south to Delray. Together these leaders formed the Michigan Home Colonization Company to encourage people to move to South Florida and be part of a new dream.

Early settlers who were dropped off at the edge of this wilderness canal would ask the boatman, "But where's Boynton?" "It's all around you," was his reply as he shoved off into the night. The pioneers were ready to experience the adventure of a lifetime. Major Boynton began constructing cottages and a hotel to serve as a winter resort for his friends and tourists from Michigan.

Construction workers flooded the area, and many of them decided to stay. As they cleared the land, they found rattlesnakes hidden everywhere. Palmetto roots had to be tediously pulled out of the ground. Horse flies would bite the workers as they painfully labored in the broiling sun. The new settlers transformed Boynton with freshly planted tomatoes, beans, peppers, pineapples, oranges, and mangoes.

S. B. Cade and L. A. King were two African Americans who farmed the muck-land north of Ocean Avenue. They were helpful to the new settlers who fought off the long-snouted razorback hogs and wild rabbits that were constantly raiding their gardens. It was a challenge to face mosquitoes as thick as dark storm clouds. Panthers screamed in the middle of the night and bears searching for turtle eggs left footprints on the beach. Pioneers in Boynton were hardy, and would not give up. An early pioneer said, "He who wants to walk under the palms must first suffer from insect bites."

For early settlers, the beach area provided a place to work. It was also a place for recreation, picnics, cookouts, camping, swimming, and church functions. People continue to enjoy these same kinds of activities today. Divers explore the amazing reefs and observe marine life located just offshore. Anglers enjoy deep-sea fishing in 800 feet of water just a few minutes from the Boynton Inlet. Just as Native Americans enjoyed this area centuries ago, future generations will continue to be blessed by this tropical treasure located at the "Gateway to the Gulf Stream." This book captures the first 100 years of life in Boynton Beach through a variety of photographs. The lively personality and development of the community is evident. This is a book of moments, feelings, and faith. No matter where one grew up, all can identify with some of the daily events that are recorded here. Hopefully, many of these vintage pictures will bring a smile to readers' faces. All royalties from this publication will go to support the efforts of the Schoolhouse Children's Museum in Boynton Beach, which continues its mission to teach children about themselves and their historical heritage.

These images help us to remember those from the past who have made a difference. As Mother Theresa once said, "We ourselves feel that what we are doing is just a drop in the ocean. But the ocean would be less because of that missing drop."

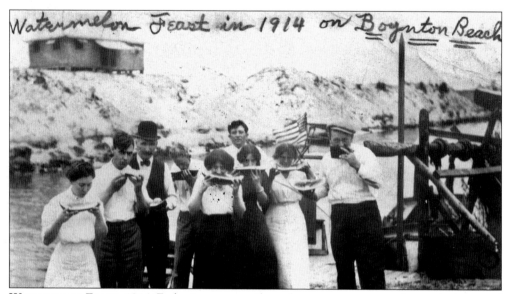

WATERMELON FEAST, 1914. Early pioneers merrily eat home-grown watermelon as the juice and seeds run down their chins. (Courtesy of Historical Society of Palm Beach County.)

One

A Tropical Frontier Called Boynton

Pioneers

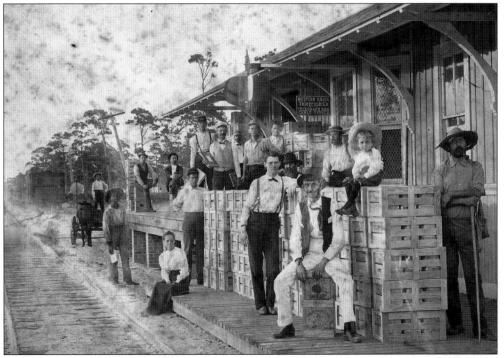

SHIPPING PLATFORM AT FEC STATION, C. 1902. Fresh tomatoes are crated and ready to ship in this picture. The pioneers gathered at the Florida East Coast (FEC) Railway shipping platform listen attentively for the train's rumble. The man holding the ledger is Charles W. Pierce, one of the legendary barefoot mailmen. If the train was on time, the crop would arrive at its northern destination in good condition, fetching a better price. A delay of any kind could mean the farmers lost money in their cash-crop venture. (Courtesy of Boynton Beach Historical Society.)

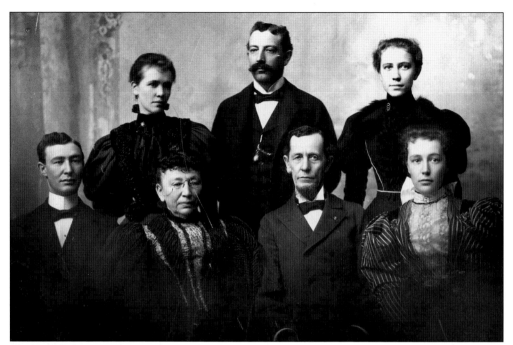

NATHAN BOYNTON AND FAMILY, C. 1895. After first visiting this primitive frontier in 1894, Maj. Nathan Smith Boynton, a Union Civil War veteran, decided to buy some property. He saw its natural beauty and potential. Returning to Port Huron, Michigan, he convinced other pioneers to come to Florida with him and join in establishing this new community. Major Boynton is the Lincolnesque looking man in the front row, second from the right. (Courtesy of Boynton Beach City Library.)

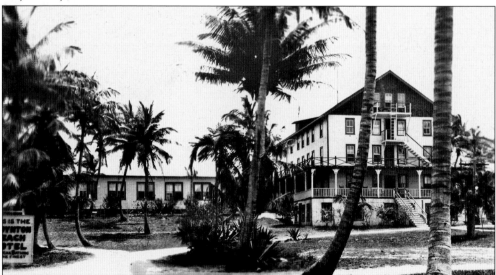

BOYNTON HOTEL, C. 1900. Boynton's hotel proclaimed, "Where Ocean Bathing is the Finest." This hotel charmed the guests who arrived by a horse-drawn surrey from the railroad. The seaside hotel's wide wrap-around porch would allow the guests to enjoy the balmy breeze and look out at the oleander and bougainvillea. This exotic paradise getaway was a vivid contrast to their Northern winters. (Courtesy of Boynton Beach City Library.)

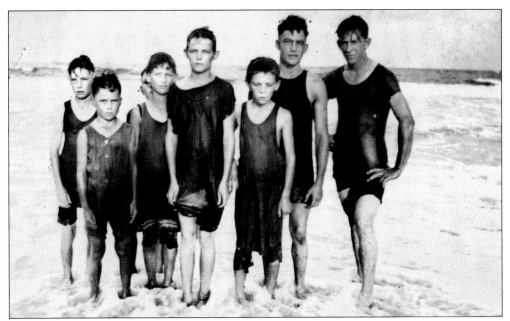

BOYS AT THE BEACH, C. 1900. One of the most pleasant pastimes for these boys was ocean bathing. Prior to 1911, the only way across the East Coast Canal (now the Intracoastal Waterway) to get to the beachside was by lighter, a type of small barge. To get to the opposite shore, passengers would have to pull the lighter in, step onto the platform, and then use the chain to pull across it. One barge was for people and the other carried a buggy or mule-cart. (Courtesy of Boynton Beach Historical Society.)

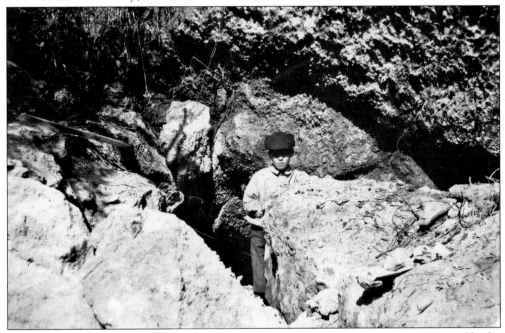

ENTRANCE TO THE CAVES, C. 1909. Peering out of the cave like Huckleberry Finn is young Charles Leon Pierce, nicknamed Chuck. He explored up and down the coast, including this cave on the ocean ridge south of the Boynton Hotel. (Courtesy of Boynton Beach Historical Society.)

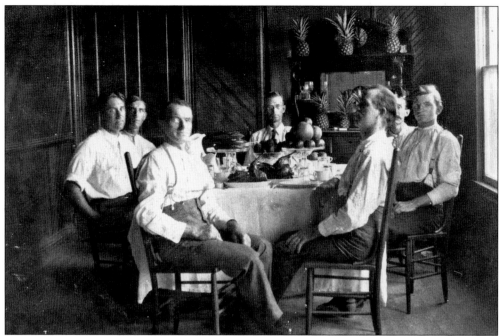

PINEAPPLES AND PROSPERITY, C. 1900. Planting pineapples was very rewarding and one of Boynton's earliest industries. Bahamians who helped the pioneers called the pineapples "pineys." Here the pineapple, which is a symbol for hospitality, decorates a dining room. (Courtesy of Boynton Beach Historical Society.)

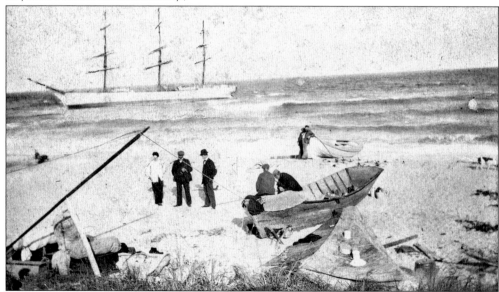

COQUIMBO SHIPWRECK, 1909. A Norwegian barkentine ship ran aground off Boynton Beach in 1909. When the ship began to break up, seagulls flew all around, attracted by the food and pieces of lumber that were floating about the ship. Federal marshals arrived to auction off the cargo of lumber to eager residents. Many of Boynton's earliest dwellings were built with the lumber salvaged from the *Coquimbo*. The ship's bell was salvaged and used as a church bell. (Courtesy of Boynton Beach Historical Society.)

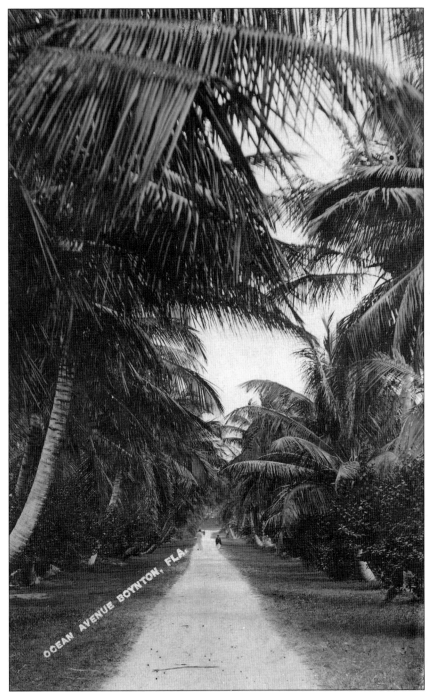

PALM-LINED PARADISE, C. 1900. Guests meander along the picturesque coconut palm–lined road that leads east to the Boynton Hotel. The palm trees in Boynton came by way of a 1878 shipwreck off Hypoluxo Island. The *Providencia*, a 175-ton Spanish brig loaded with 20,000 coconuts, had sailed from the island of Trinidad. Salvagers who sold the edible cargo unintentionally provided seedlings for trees that one day would inspire Palm Beach County's name. (Courtesy of Boynton Beach Historical Society.)

ISLAND PICNIC, C. 1900. Hypoluxo Island, just north of Boynton, is where these residents frolicked on weekends and holidays. The men are using their handkerchiefs to stifle the pesky mosquitoes and sand flies that have joined the picnic. At home, smudge pots were used to keep the heavy swarms of mosquitoes away, and a palmetto frond worked as a brush to rid oneself of the insects before entering the home. (Courtesy of Boynton Beach Historical Society.)

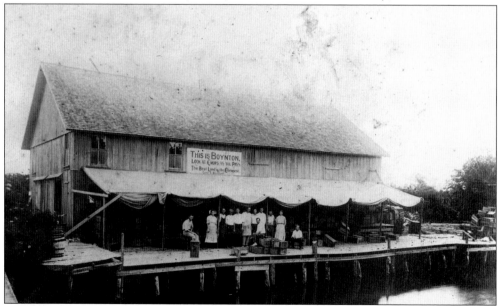

"THIS IS BOYNTON," C. 1910. Packing shed workers greet passing boaters with Southern hospitality as they take a break from the laborious task of sorting and packing tomatoes. The sign above the wooden waterfront platform reads, "This is Boynton, Look at the Crops as you Pass By, the Best Land is The Cheapest." (Courtesy of Boynton Beach Historical Society.)

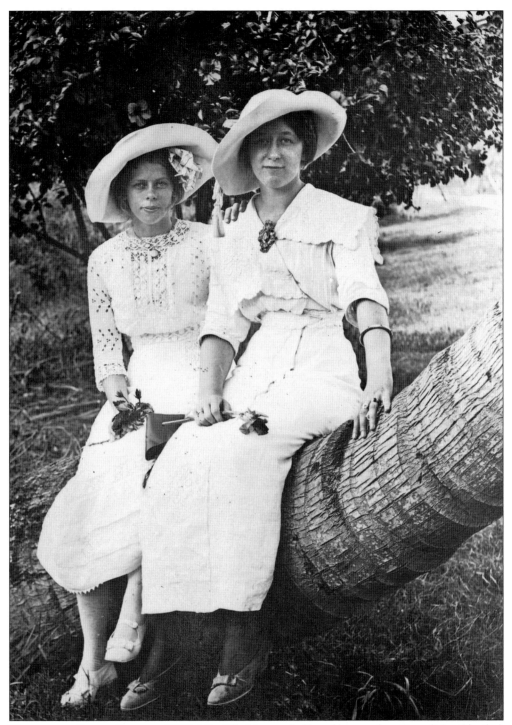

UNDER THE SHADY PALM, C. 1900. Miss Ella Harper (left) and her mother, Cora (Mrs. Charles) Harper, rest in the nook of a coconut palm with a background of red hibiscus. Mrs. Charles Harper served as the first president of the Boynton Woman's Club, from 1909 to 1911. (Courtesy of Boynton Beach Historical Society.)

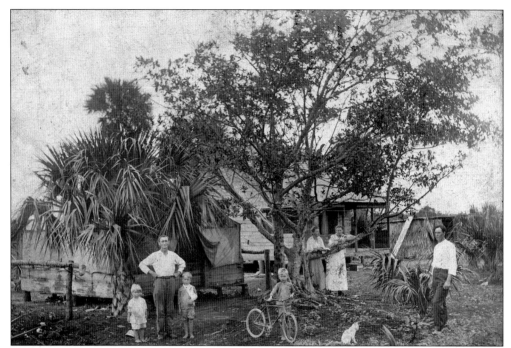

WOOLBRIGHT HOMESTEAD, C. 1912. These children enjoyed playing under the shade of the tree in their front yard. The newly planted palm trees, white kitten, and playful children remind us that this was a new beginning for the pioneers. The Woolbright family farmed and ran a successful pineapple plantation. (Courtesy of Helen Adams Meisenheimer.)

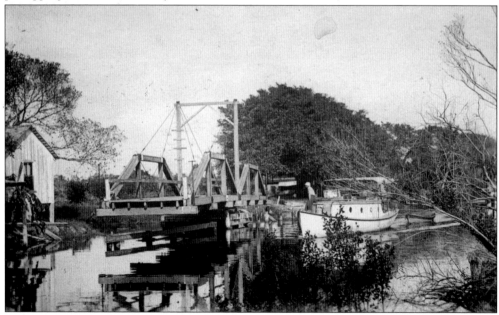

FIRST BRIDGE, 1911. This first wooden bridge over the East Coast Canal was located on Ocean Avenue and linked the town to the beach. The ingenious bridge was operated by the means of a crank. The bridge-tender walked around in a circle, pushing until the whole section of the bridge swung open. (Courtesy of Boynton Beach Historical Society.)

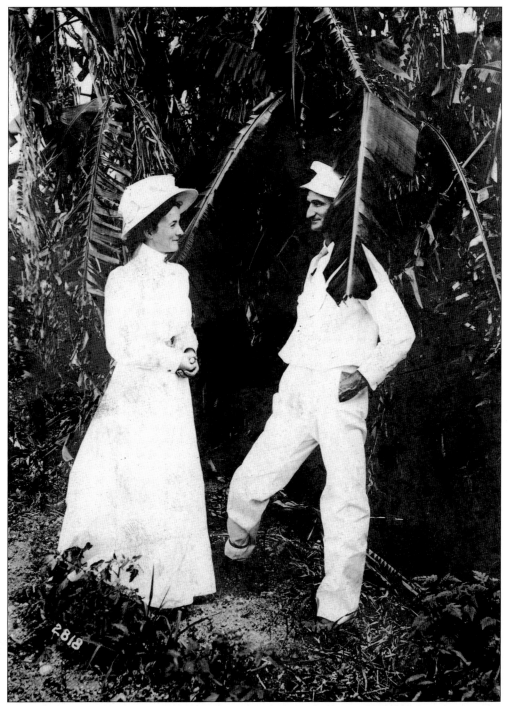

LOVE UNDER THE BANANA TREE, 1908. Mr. and Mrs. Charles C. (Nellie) Mast pause under the shade of banana trees. Mr. Mast wears a "pants guard" on his right leg. Bicycles were popular means of transportation in the early 20th century. Romantic gifts from this era often came from alligator and shark teeth, which were used to make necklaces, brooches, and other exotic jewelry. (Courtesy of Boynton Beach Historical Society.)

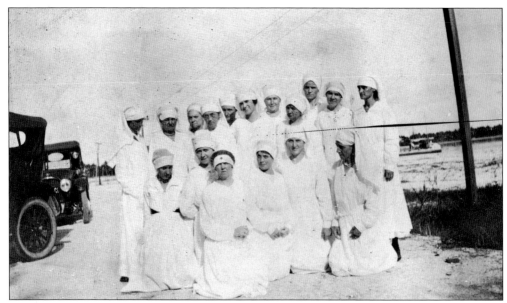

Women's Unit of the American Red Cross, 1917. The Women's Unit of the American Red Cross (ARC) assembles in Boynton wearing their official uniforms. Clara Barton founded American Association of the Red Cross in 1881. By the time World War I ended in 1918, almost 20 percent of the population of the United States had become members of the ARC during the war. (Courtesy of Boynton Beach City Library.)

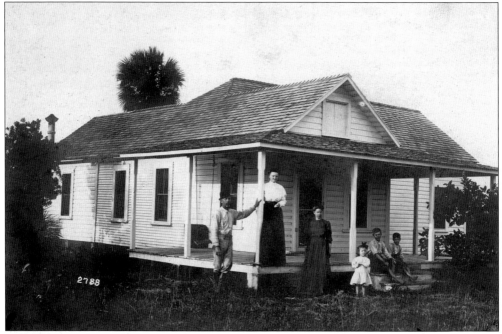

Pioneer House, 1908. Homes were built to protect and shelter families from the harsh Florida sun. M. B. Lyman and his family lived in this house, which typified the homes of the time. The wrap-around slanted roof, many windows, and wide porch, along with southeasterly ocean breezes, helped cool the home all year round. (Courtesy of Boynton Beach Historical Society.)

CHARLES PIERCE: BAREFOOT MAILMAN, 1920S. One of Boynton's earliest pioneers was Charles W. Pierce, who was born in 1865 in Waukegan, Illinois. His father, Hannibal, was the assistant lighthouse keeper on Jupiter Island. Before moving to Boynton from Hypoluxo in 1895, Charles was one of the 11 barefoot mailmen. Starting in the 1870s, the beach-walking mail route from Jupiter to Miami was a three-day journey with overnight stays at the Houses of Refuge for ship-wrecked sailors in Delray Beach and Fort Lauderdale. The saltwater would destroy shoes, so dedicated mail carriers walked barefoot along the water on the packed sand with pants rolled up to their knees. (Courtesy of Boynton Beach City Library.)

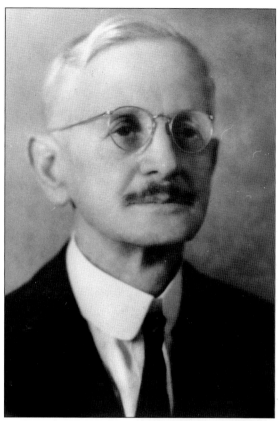

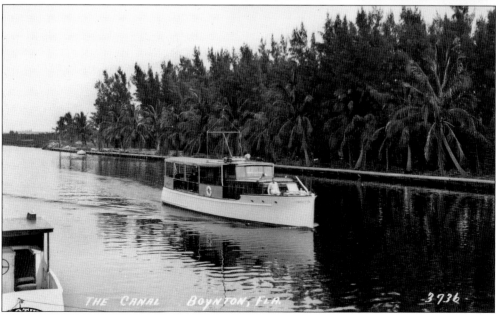

THE CANAL LOOKING NORTH, C. 1920. In the early 1920s, people would often take a scenic boat ride for their shopping and holidays. This canal would later be widened and become part of the Intracoastal Waterway to make navigation safe. (Courtesy of Boynton Beach City Library.)

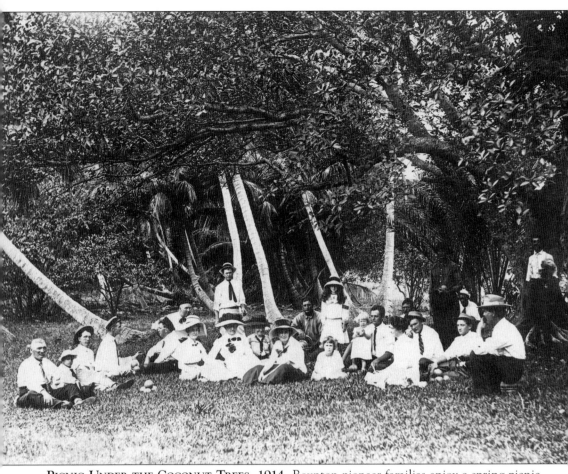

PICNIC UNDER THE COCONUT TREES, 1914. Boynton pioneer families enjoy a spring picnic on Hypoluxo Island under the coconut trees in this image. They traveled to the island from Boynton by Jesse Daugharty's boat along the East Coast Canal. There were few roads or bridges then. The people attending were the families of the Daughartys, Maulls, Funks, Masts, Weavers, Bensons, and the Jeuseus. Picnic food was fried chicken, deviled eggs, potato salad, sliced tomatoes, swamp cabbage, fresh sliced pineapple, corn pone, cold biscuits, pies of sweet potato, huckleberry, custard, and lemon meringue, guava ice cream, and cake with freshly grated coconut. (Courtesy of Boynton Beach Historical Society.)

Two

HENRY FLAGLER'S RAILROAD TO PARADISE
Trains

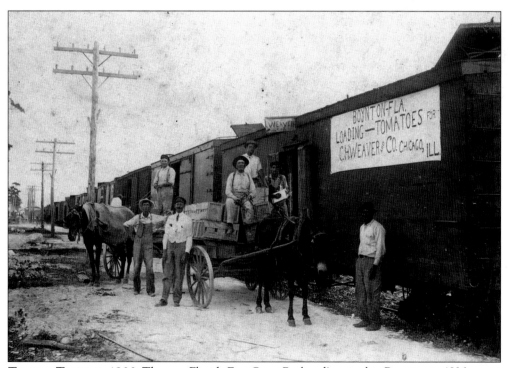

TOMATO TRAIN, C. 1900. The new Florida East Coast Railroad's arrival in Boynton in 1896 meant that farmers could now ship their tomatoes up north. If the train derailed or broke down, pioneers sadly had to dump their boxes of rotting tomatoes into the canal, turning it into a red sea. Furniture and provisions to ensure a more comfortable life could now be ordered from the Montgomery Ward Company and transported by train. (Courtesy of Boynton Beach Historical Society.)

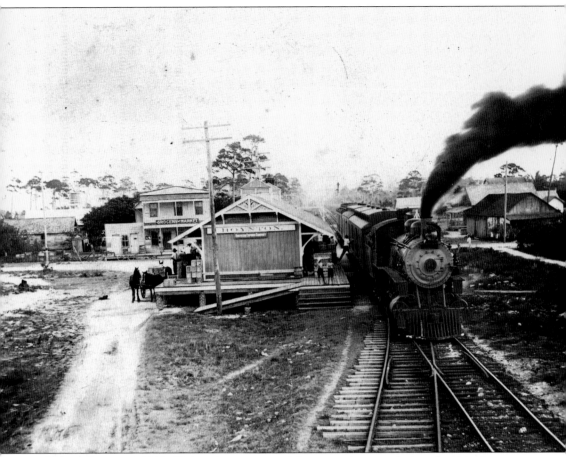

TRAIN STATION, 1913. This train was a special express that ran during the shipping season, which was April and May. The white-rock road running horizontally in the photograph is Ocean Avenue. The two-story building opposite the station housed a grocery store on the first floor with living quarters above. The two men unloading tomatoes from the horse-drawn wagon are Fred Benson and Arthur Stephens. The train whistle was a source of communication and could signal impending bad weather to the residents. Six haunting blasts warned the farmers that the mercury was forecast to dip below freezing. (Courtesy of Boynton Beach Historical Society.)

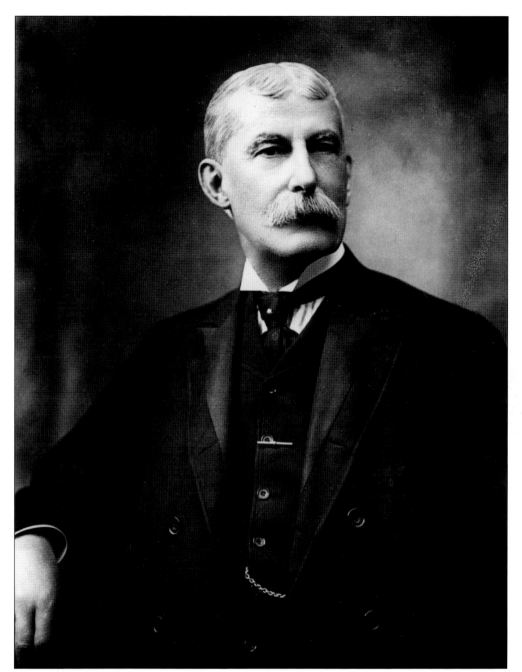

HENRY MORRISON FLAGLER, C. 1900. The most powerful personality to shape the future of South Florida was Henry Morrison Flagler. He built the rails and the hotels from Jacksonville to Key West. His railroad literally created towns like Boynton, because new settlements would spring up alongside the railroads. Flagler offered one free round-trip on his railroad to any settler who bought land. As the son of a Presbyterian minister, he came from very humble beginnings. A brilliant man of great vision, he would later become a John D. Rockefeller partner and railroad builder. The Florida East Coast Railroad would open the door of prosperity for Boynton. Flagler contributed $750 towards building the first church in Boynton. (Courtesy of Historical Society of Palm Beach County.)

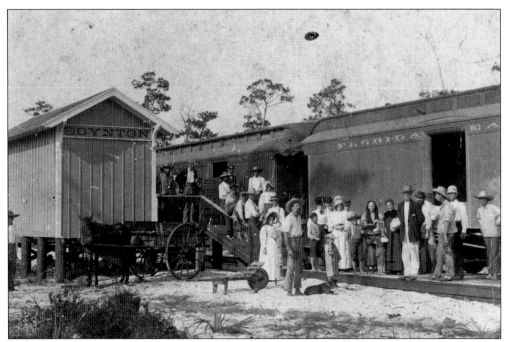

TRAIN STATION GATHERING, 1890s. Beginning in 1883, all Flagler buildings were to be painted bright yellow with green shutters. Standing next to this cheerful yellow train station are sharply dressed townspeople wearing hats to shade themselves from the broiling sun. If they were traveling north, there would be opportunities for them to stay at a Flagler hotel and feast on fresh vegetables and fruit. (Courtesy of Boynton Beach Historical Society.)

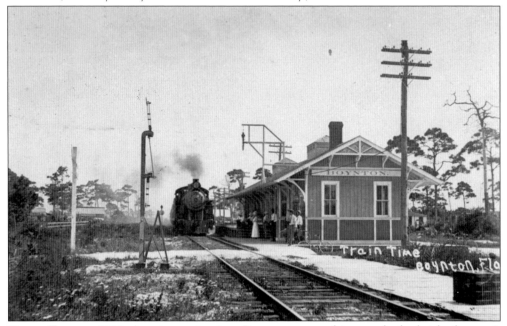

TRAIN TIME, C. 1910. A train coming into Boynton meant this town had a bright future. A pioneer village could not blossom without a train depot as a way to ship goods and connect with other parts of the country. (Courtesy of Boynton Beach Historical Society.)

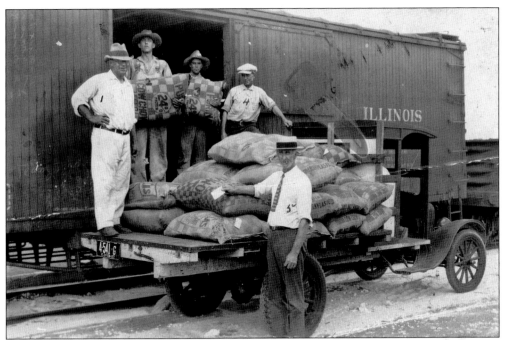

UNLOADING THE TRAIN, C. 1927. Men unload a train car of feed at the Boynton station. They are putting the bags of Purina Cow Chow on a Model T Ford truck to be transported to M. A. Weaver's feed store on Ocean Avenue and to the local dairy farms. Pictured, from left to right, are M. A. Weaver, Curtis Hathcock, Herb Keatts, Frank Muggleton, and E. F. Crumless. (Courtesy of Boynton Beach Historical Society.)

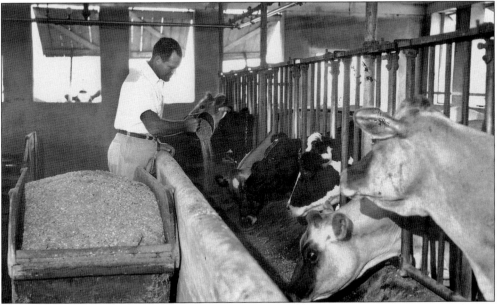

CHOW TIME, 1950S. Distributing feed to the cows at Weaver Dairy is Marcus Weaver, son of M. A. Weaver, who came to Boynton in 1909. M. A. Weaver farmed at first and then worked for Ward Miller's Dairy. Later he owned and operated his own very successful dairy and served as one of Boynton's early mayors. (Courtesy of Boynton Cultural Centre.)

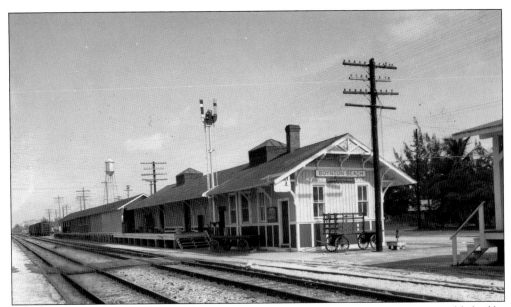

RAILROAD STATION, 1940s. In the beginning days of the community, Boynton was established by people who bought land from the railroad company. Henry Flagler offered a temporary reduction in freight rates on citrus shipped over his lines. The Model Land Company would often give different kinds of seeds to settlers to encourage farming. The railroad continued to grow and expand into the new century. (Courtesy of Boynton Beach City Library.)

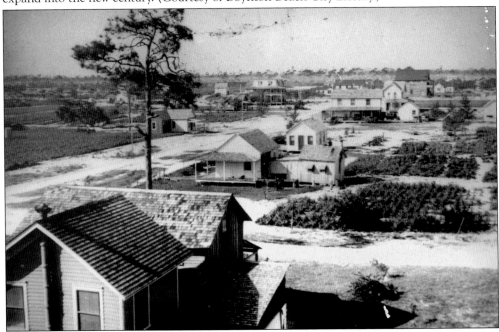

THE TOWN GROWS, C. 1915. In a rare view of Boynton taken from the belfry of the new 1913 Boynton School on Ocean Avenue looking west, the town looks to be taking shape. Settlers have homesteaded the area, and backyard gardens are flourishing. Hungry children could count on a nutritious snack from the plentiful sweet potatoes roasting on a wood stove. (Courtesy of Boynton Beach Historical Society.)

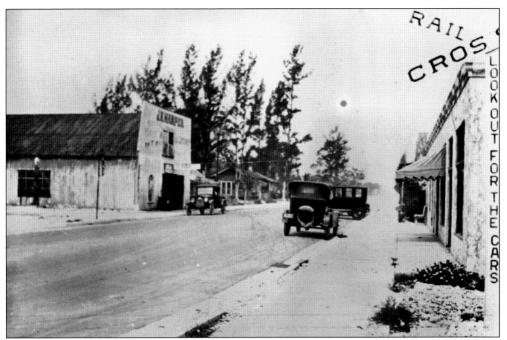

TRAIN CROSSING, 1927. This view is of the FEC train crossing on Ocean Avenue looking west from the tracks. A major hurricane had come on September 10, 1926, bringing a blow to the economic boom. Two years later, on September 16, 1928, one of Florida's worst hurricanes passed over the area and continued on to Lake Okeechobee. (Courtesy of Boynton Beach Historical Society.)

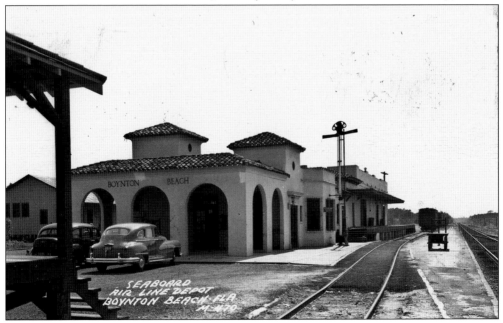

SEABOARD AIR LINE RAILWAY STATION, 1940s. Seaboard Air Line railway station, built in 1926, was located on the west side of Boynton Beach. Since Boynton was not a scheduled stop, the train had to be flagged down if a passenger wanted a ride. (Courtesy of Boynton Beach Historical Society.)

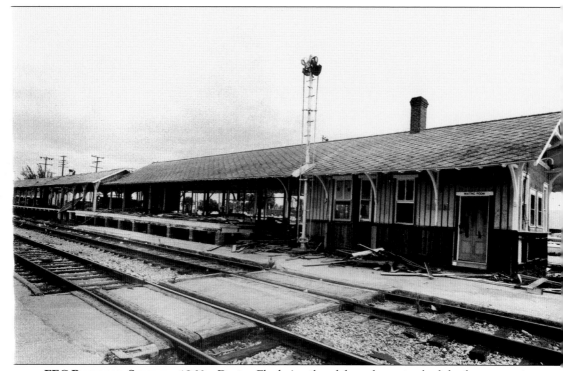

FEC Railroad Station, 1960s. During Flagler's railroad days, the region had the fastest growing population in the state. In the 1890s, Dade County grew almost 500 percent. In response, the legislature created the new county of Palm Beach from the northern part of Dade in 1909. During this time, the railway stations bustled with newcomers. By the 1960s, many FEC train stations had become dilapidated, and were torn down. (Courtesy of Boynton Beach City Library.)

Three

HOOKED IN THE MOUTH OF THE GULF STREAM
Fishing

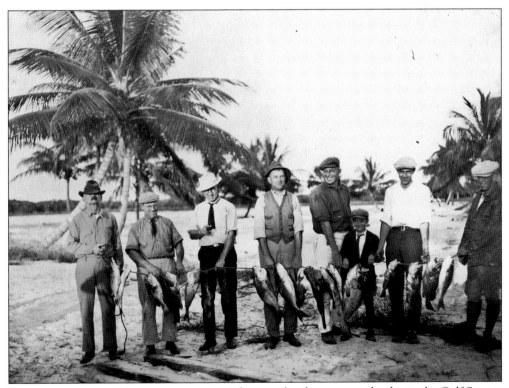

FISHING PARTY, 1926. As was customary at the time, local men spent the day in the Gulf Stream waters catching their fill of grouper, strawberry rine, perch, and warsaw fish. First Capt. Joseph C. Powell and his son Joseph Jr. are on the left. Mr. Powell was the bridge-tender. His daughter tended the bridge on his day off so he could go fishing. (Courtesy of Boynton Beach Historical Society.)

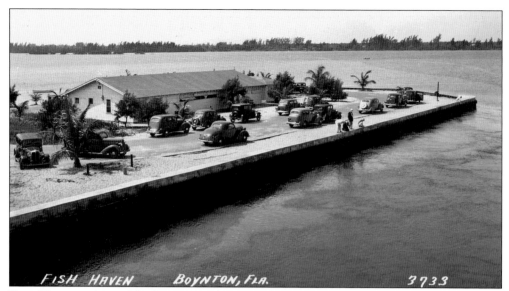

FISH HAVEN, 1940s. The Boynton Inlet opened in 1926 and was a popular destination for fishermen and spectators. They drove from miles around, packing their fishing gear and lunches into their automobiles. (Courtesy of Boynton Beach Historical Society.)

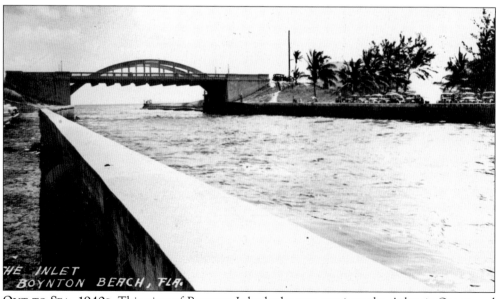

OUT TO SEA, 1940s. This view of Boynton Inlet looks east, out into the Atlantic Ocean and the clear blue waters of the Gulf Stream. (Courtesy of Boynton Beach Historical Society.)

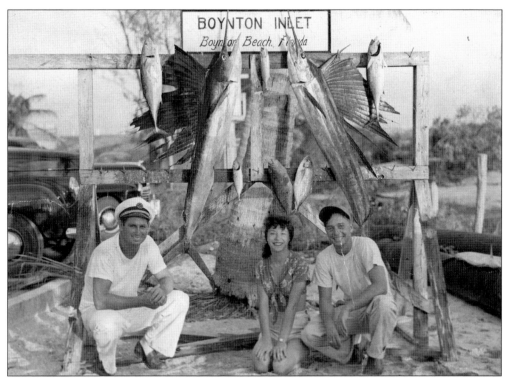

LOVE BIRDS AND SAIL FISH, 1947. Capt. Herbie Schultz is shown with mate Tom Pearson and Tom's new bride, Edna. (Courtesy of Jim and Leah Pisarski.)

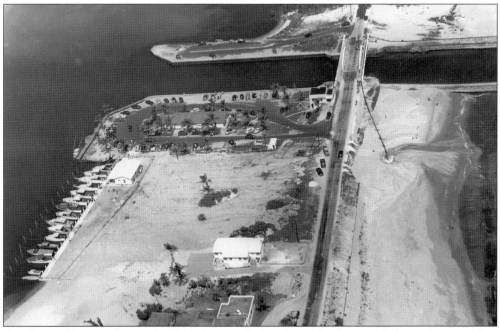

BIRD'S-EYE VIEW OF INLET, 1950S. This aerial view shows the Boynton Inlet and surrounding area as seen from above, looking north. The pipe is pumping sand out of the inlet to replenish the beach. (Courtesy of Boynton Beach Historical Society.)

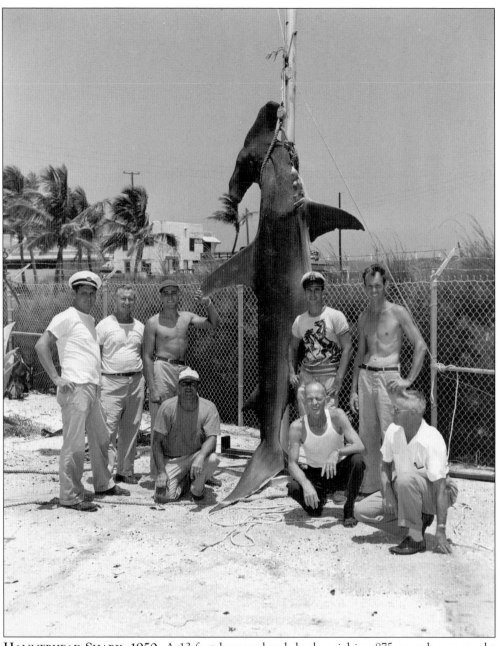

HAMMERHEAD SHARK, 1950. A 13-foot hammerhead shark weighing 875 pounds was caught August 2, 1950, by Capt. Herbie Schultz and his crew. (Courtesy of Jim and Leah Pisarski.)

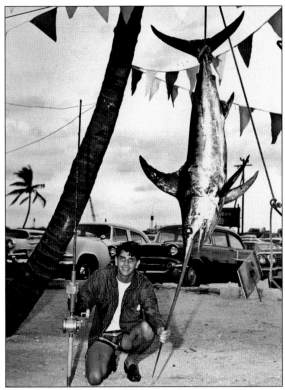

TEEN WITH SWORDFISH, 1950S.
A teenager glows with pride after successfully hooking a broadbill swordfish using a fiberglass Bimini twist reel. Weighing over 500 pounds, and with a razor-sharp bill nearly two feet long, this fish probably put up a real fight. (Courtesy of Mrs. Homer Adams.)

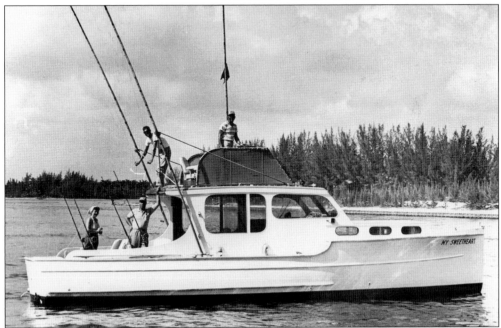

MY SWEETHEART, 1950S. Homer Adam's boat *My Sweetheart* passes through the inlet on a sunny day. Bumps in the solid wood poles indicate Calcutta fishing poles. Beer Can Island in the background is now a bird sanctuary protected by the Audubon Society. (Courtesy of Mrs. Homer Adams.)

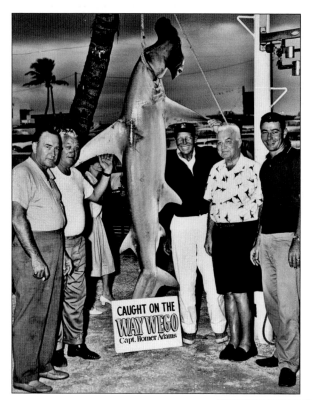

CAUGHT ON THE WAYWEGO, 1950s. With storm clouds looming in the background, these winter tourists display a hammerhead shark. The hammerheads are perhaps the most easily recognizable of sharks as they all have a pronounced lateral expansion on each side of the head. If it was an off-day for fishing, a sea captain could appease tourists by landing a shark. (Courtesy of Boynton Cultural Centre.)

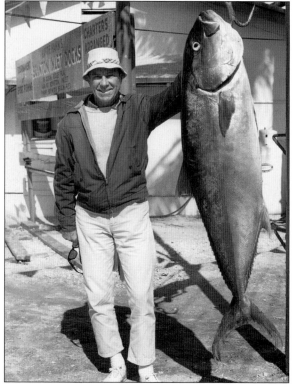

THE AMAZING AMBERJACK, 1950s. Displayed at the Boynton Inlet Docks Tournament is an 821-pound amberjack caught on the *Helen Ann* by Wayne Pate of Ocean Ridge. This catch was especially revered because of the delicious, sweet, tender meat that is found below the eye in the cheek of the fish. (Courtesy of Boynton Beach City Library.)

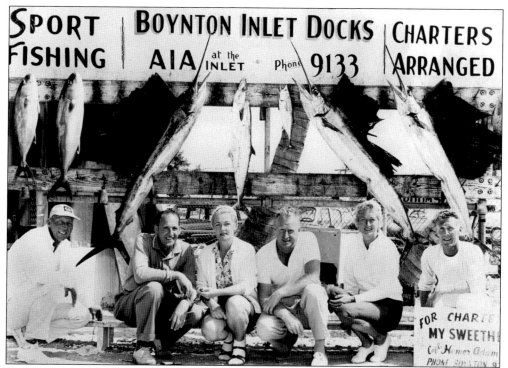

CHARTERS ARRANGED, 1950S. Capt. Homer Adams was one of many local skippers who arranged sport-fishing outings for tourists. Legend has it that every boat captain at the dock said it was the worst business to get into, but each year they came back because the sea was in their blood. (Courtesy of Mrs. Homer Adams.)

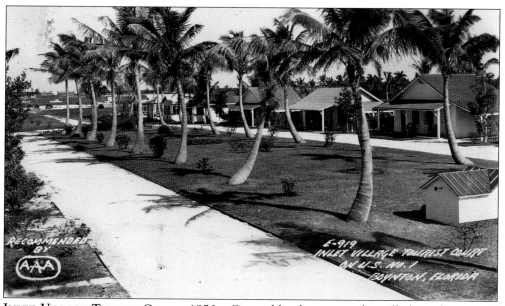

INLET VILLAGE TOURIST COURT, 1950S. Courts like these popped up all along the coast of Florida to provide tourists with a place to stay. These cottages were a peaceful oasis where the average person could stay on vacation. (Courtesy of Boynton Beach Historical Society.)

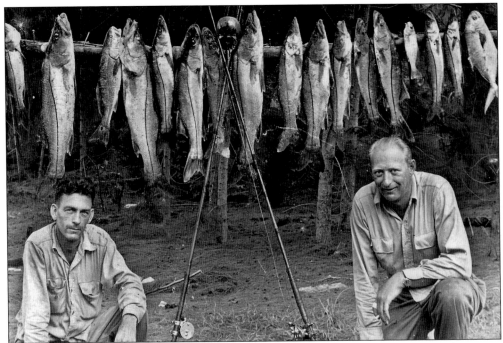

FISHING TABLEAU, C. 1948. Captain and noted photographer Larry Witt, the man on the right, has arranged these fish into an artistic inlet tableau. Framed by Australian and Brazilian pines, the picture is anchored in the center with a rare red fish and a horseshoe crab, along with the solid Calcutta fishing rods and Shakespeare service reels. (Courtesy of Grady Stearns.)

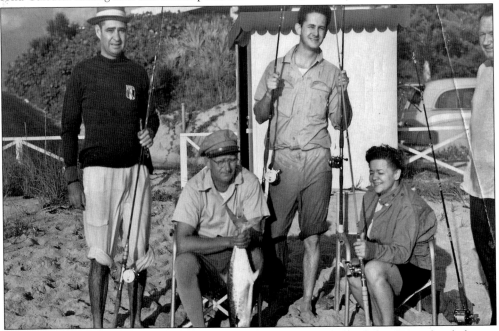

SURF FISHING, C. 1949. Sitting in front of the beach cabana behind the Couse family home, Captain Witt holds up a prize mackerel caught while surf fishing off John Couse Reef. (Courtesy of Grady Stearns.)

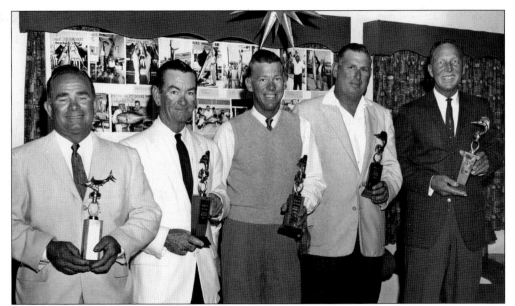

THE SEA CAPTAINS, 1950S. In this image, Boynton Beach sea captains gather together to receive recognition from the city for providing many happy experiences to visitors and tourists. Holding their Silver Sailfish awards, from left to right, are Captains Lyman, Keene, Lunsford, Shultz, and Adams. (Courtesy of Boynton Beach City Library.)

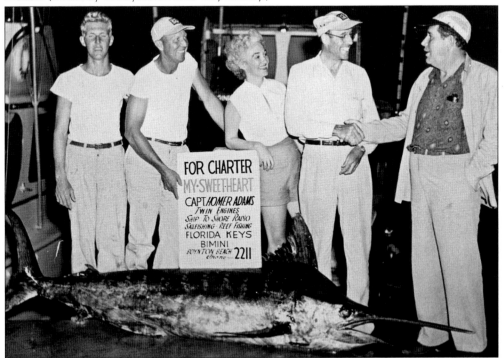

A 271-POUND BLUE MARLIN, 1950S. This 271-pound marlin was caught aboard the charter boat *My Sweetheart*. Sometimes sharks would prey on the fish before it was brought ashore. The neighborhood fish markets were happy to buy the marlin to smoke the meat and make fish spread. (Courtesy of Mrs. Homer Adams.)

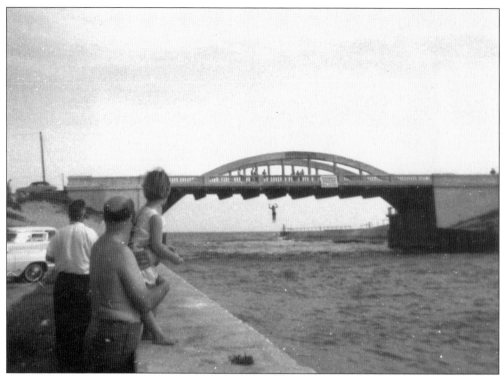

HIGH JINKS AT THE BRIDGE, 1960S. Onlookers watch as a youth gets a thrill jumping from the arches of the Ocean Inlet Bridge. This was very risky, especially when the strong currents of the tide were going out to sea. (Courtesy of Susan Sinclair.)

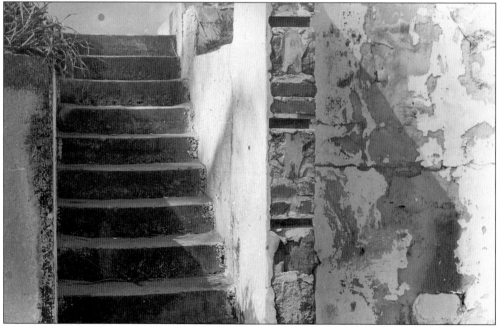

STAIRWAY TO THE SEA, 1970. These rustic stairs under the bridge form a passageway to Highway A1A and out into the balmy breeze and salty air of the coast. (Courtesy of Natalie Malison.)

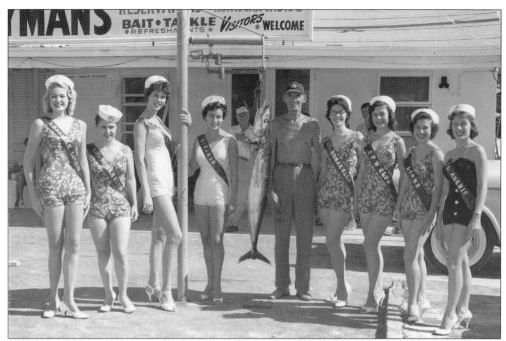

MISS MERMAIDS, 1950s. Adding to the nautical atmosphere at Lyman's Dock, the lovely Boynton Beach Mermaids greet fisherman Louis Charles from Long Island. These young women represented various civic clubs and organizations. They are seen sporting sashes from the American Legion, Boynton Woman's Club, Kiwanis, the Business and Professional Woman's Club, and the Lions Club. (Courtesy of Boynton Beach City Library.)

A BIG MESS OF FISH, 1950s. The bounty of fish caught this day in the Atlantic Ocean includes red snapper, mutton, kingfish, and grouper. (Courtesy of Boynton Beach City Library.)

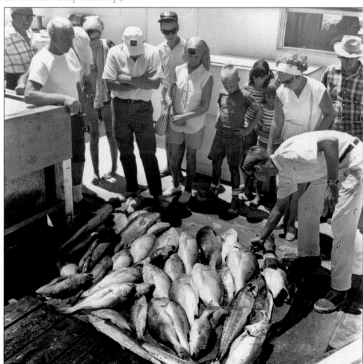

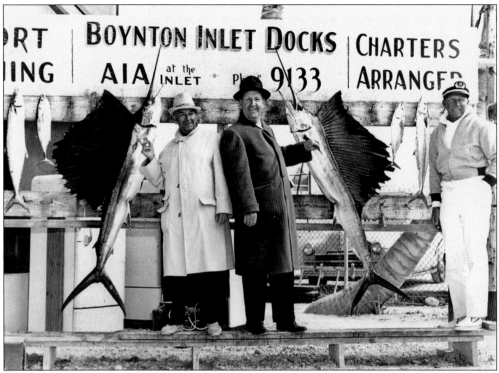

CHILLY FISHING, 1950s. Even on brisk days, tourists had a splendid time fishing and reeling in their catch. Kingfish and bonita balance this pair of female sailfish. (Courtesy of Mrs. Homer Adams.)

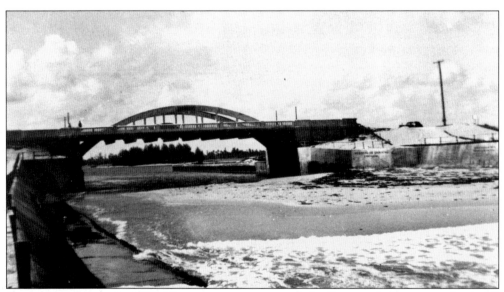

INLET AFTER STORM, 1958. Two major storms caused the Boynton Inlet to completely fill in with sand. The bridge links Manalapan and Ocean Ridge. The seawalls and jetties attract fishermen and people who enjoy watching the boats go out to sea. (Courtesy of Boynton Beach City Library.)

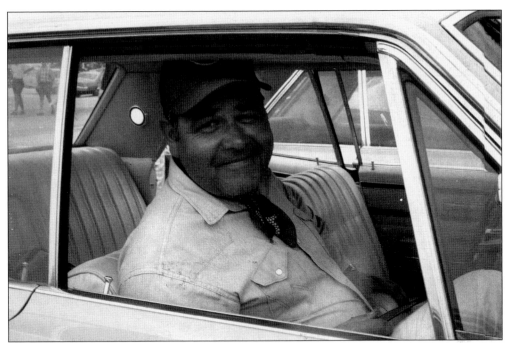

JONATHAN WINTERS, 1960s. Comedian Jonathan Winters visited Boynton Beach to take a break from his fast-paced life. He was the star of his own television show in the 1960s. Winters fished for two days to get away from the pressures of Hollywood. Later on, he would incorporate a fishing skit into his comedy act. (Courtesy of Boynton Beach City Library.)

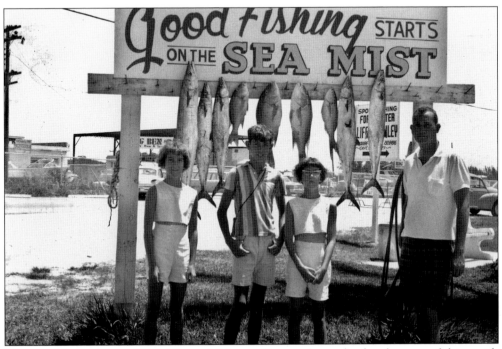

MAKING MEMORIES, C. 1960. These children will never forget the day they went fishing with their dad on the *Sea Mist*. (Courtesy of Boynton Beach City Library.)

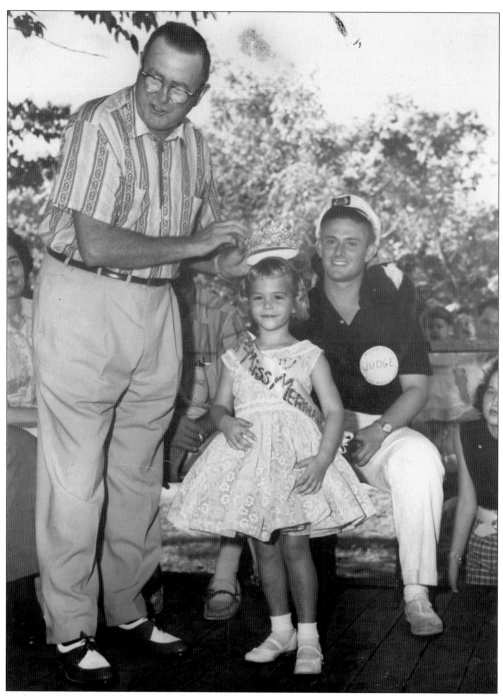

LITTLE MISS MERMAID, 1960s. An adorable little girl is crowned Little Miss Mermaid at the annual fishing tournament. From the 1940s to 1960s, sport fishing was a major part of Boynton Beach's economy, drawing thousands of fishermen to Boynton for the world's finest fishing. Many regarded it as the town's biggest industry. The four-day contest drew sport fishermen from as far north as Stuart, and from Fort Lauderdale to the south. (Courtesy of Boynton Beach City Library.)

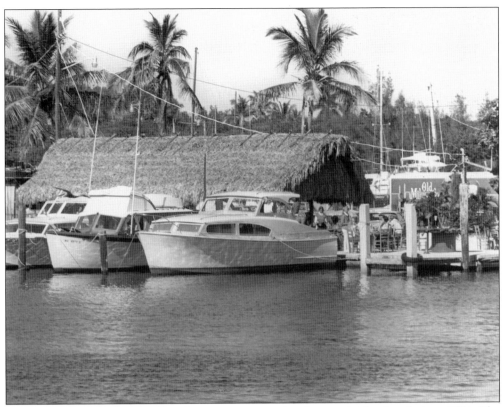

TWO GEORGES, 1960S. The Two Georges restaurant has been a city landmark since 1954. The locals as well as many tourists stop in by land and by sea for their famous conch fritters. It is known for its Seminole-style chickee hut. (Courtesy of Boynton Beach City Library.)

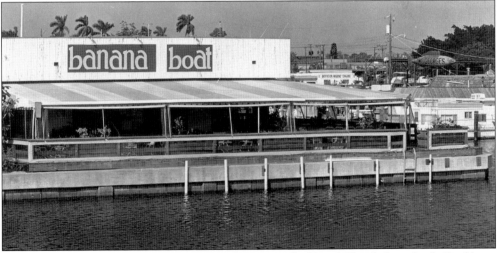

BANANA BOAT, C. 1978. The Banana Boat is known in all of South Florida for its lively Caribbean music, fresh seafood, and festive atmosphere. (Courtesy of Boynton Beach City Library.)

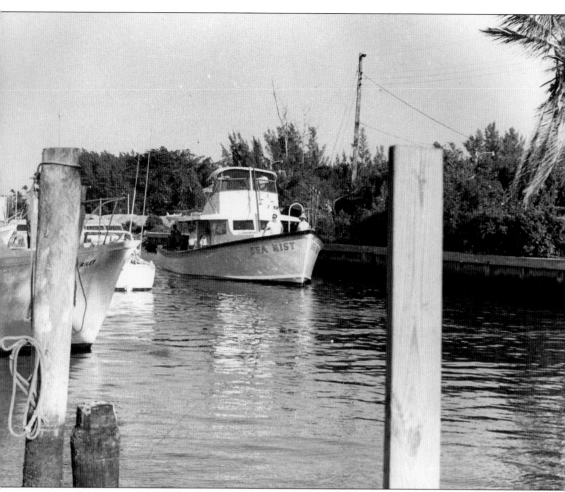

THE SEA MIST, 1970. The Sea Mist Marina sprang to life in 1956 as the home of one of the state's premier charter fishing fleets. Later, when the sport-fishing industry waned, the Sea Mist Marina became available for pleasure, diving, and commercial fishing boats. (Courtesy of Natalie Malison.)

Four

SUN AND FUN
The Beach

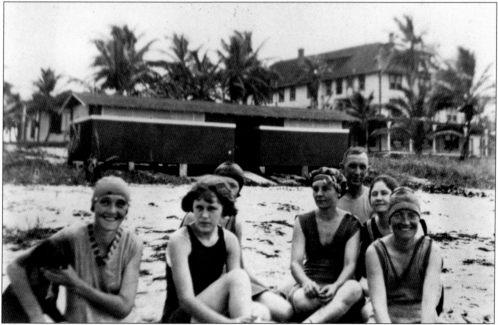

FUN ON THE BEACH, 1920S. The guests who stayed at the Boynton Hotel enjoyed the beautiful wide beach. The bathhouses are shown in the background. The youngsters who grew up in Boynton during the 1920s had great fun exploring the open land and wide, mostly deserted beaches. Many 4-H groups had camp-outs on the beach, and made soft beds out of sand, moss, and a blanket. A weenie roast and a campfire added to their pleasure. Sometimes a great sea turtle would come ashore to nest and lay eggs. The boys and girls learned to fish with a tree branch, string, and a safety pin. (Courtesy of Boynton Beach City Library.)

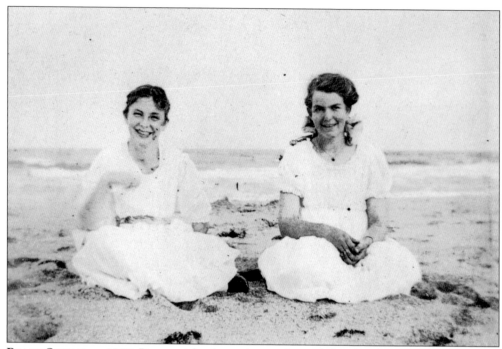

BEACH OUTING, C. 1900. Pioneer girls relax and enjoy the sandy beach. The white cotton clothing helped to reflect the sun and keep them cool. (Courtesy of Boynton Beach Historical Society.)

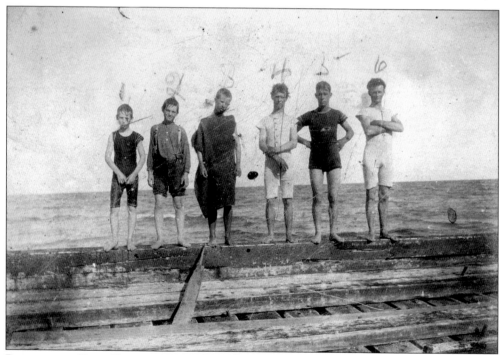

BOYS AT THE BOAT RAMP, C. 1900. Some boys wear homemade swim attire and others wear store-bought woolen swimsuits for leisure time at the beach. (Courtesy of Boynton Beach Historical Society.)

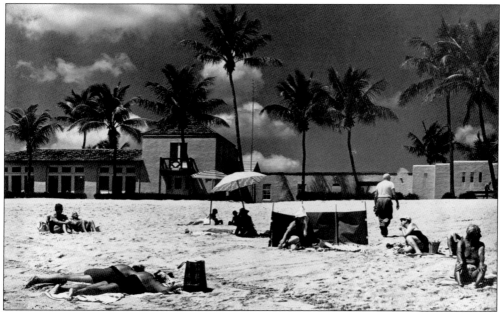

BOYNTON BEACH CASINO, 1960S. Boynton's public bathhouse and picnic pavilion was called the Boynton Beach Casino. The popular place of recreation was located on A1A in Boynton just south of its successor, the present-day Boynton Beach Oceanfront Park. In 1946, Lucille and Otley Scott rented the building for their well-known restaurant. People would come from miles around for their famous mile-high lemon meringue pie. (Courtesy of Boynton Beach Historical Society.)

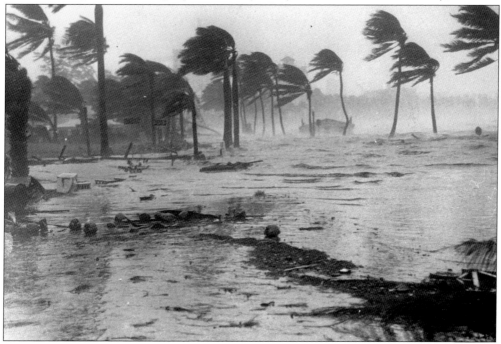

HURRICANE HOWLS, 1947. One of the worst of hurricanes to hit Boynton destroyed many of the coconut palms in Boynton Beach. The water surged over the road by the casino. (Courtesy of Boynton Beach City Library.)

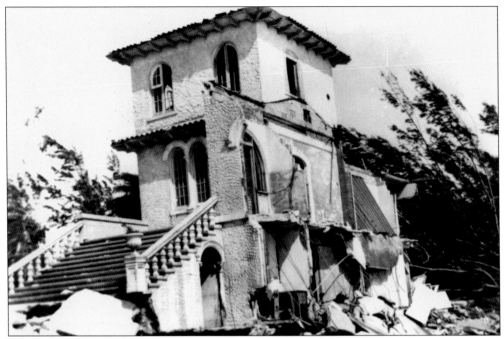

BRINY BREEZES, 1947. Travelers with trailers were allowed to park overnight on the property of Mr. Ward Miller if they would buy some of his strawberries. Eventually, this grew into a regular trailer-park business. In 1947, the palatial Miller home was destroyed by a powerful hurricane. Today the site is home to the Briny Breezes Clubhouse. (Courtesy of Boynton Beach Historical Society.)

A DAY AT THE BEACH, 1950S. Teenagers hang out at the beach at the Boynton Beach Casino. A popular activity was sunbathing while listening to rock-n-roll on the newly invented transistor radio. (Courtesy of Boynton Beach Historical Society.)

BOYNTON BEACH WELCOMES YOU, 1950S. A Boynton Beach Chamber of Commerce brochure promotes the ocean, fun, fishing, and sunshine so abundant in this area. (Courtesy of Boynton Beach City Library.)

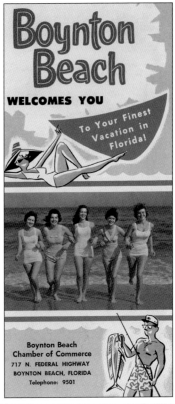

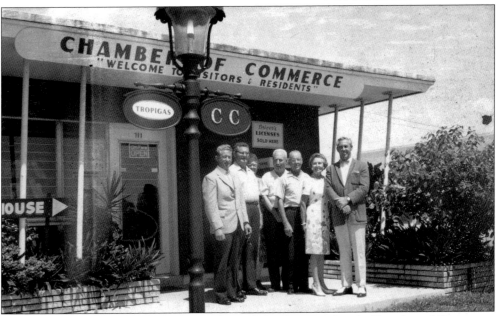

CHAMBER OF COMMERCE, 1960S. Members of the Boynton Beach Chamber of Commerce greet new businesses, residents, and guests with smiling faces. Ann Barrett (second from right) was instrumental in starting the Boynton Beach Chamber of Commerce. (Courtesy of Boynton Beach City Library.)

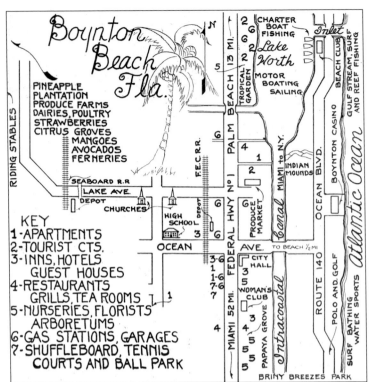

TOURIST MAP, 1940S.
This guide showcases
the local attractions
around Boynton Beach.
Tourist courts and
farms fanned out to
the west. Sailing, surf-
bathing, and Indian
Mounds are to the east.
(Courtesy of Boynton
Cultural Centre.)

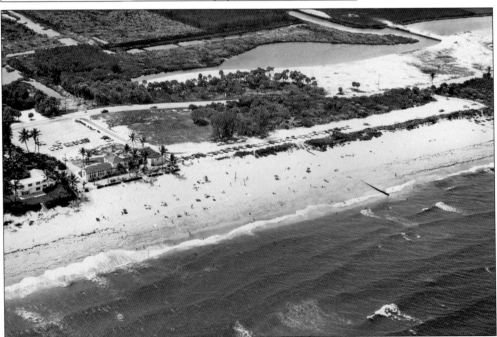

AERIAL VIEW OF BEACH, 1950S. During World War II, Allied ships became targets for German submarines that were lurking just off the shore of Boynton Beach. Access to the beach was limited and there were partial blackouts during those years. Cars driven at night on A1A were required to have their headlights partially painted out. (Courtesy of Boynton Beach Historical Society.)

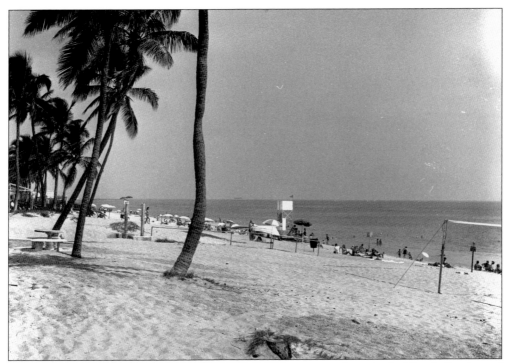

THE GULF STREAM, C. 1960. The strong ocean current runs through the Florida Straits and takes shape in the Gulf of Mexico, showing up as a ripple in the water about a mile offshore. The strong current travels as fast as three miles per hour. Early sailors used the current to speed the voyages from America to Europe. (Courtesy of Boynton Beach City Library.)

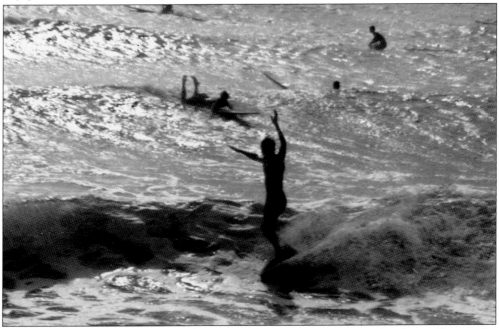

TOM TERRIFIC, 1960s. A local surfer known only as "Tom Terrific" rides the swells near the inlet. (Courtesy of Boynton Beach City Library.)

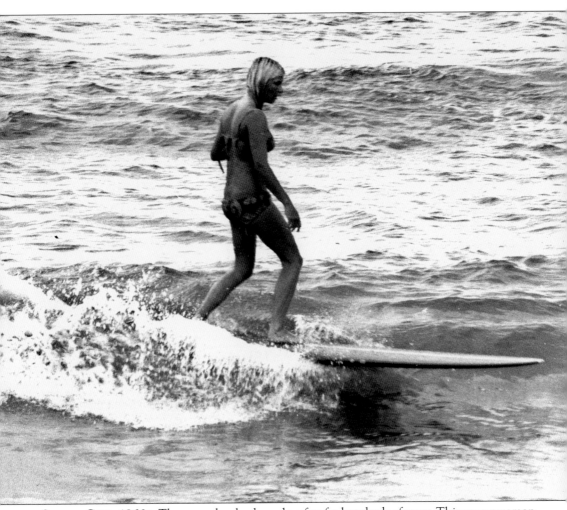

SURFER GIRL, 1960S. The ocean has beckoned surfers for hundreds of years. This young woman shows the grace and balance of someone who has mastered the art of surfing. She paddles her board out to face the open sea, with white gulls flying overhead. Bobbing on her board, she chooses a wave and paddles furiously towards the shore. Suddenly, the approaching wave surges under her board. The surfer stands up, and feels the incredible rush that comes from catching an emerald wave. (Courtesy of Boynton Beach City Library.)

Five

LOOK AT THE CROPS AS YOU PASS
Farming

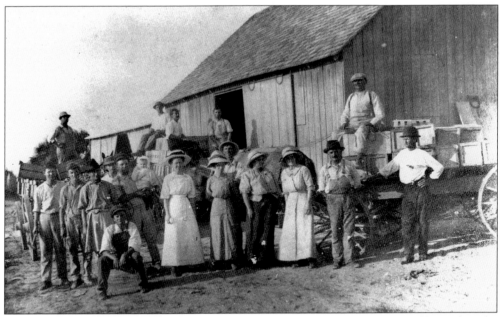

TOMATO PACKING HOUSE, 1913. This packinghouse was built by C. C. Mast and located on the East Coast Canal. The weight of each wooden crate of tomatoes was approximately 50 pounds. In the early 20th century, farmers would make $2 in profit on a crate. In those days, this was enough to pay their bills. Empty tomato crates were sometimes used for chairs in early homes. Horses were draped with burlap soaked in a yellowish, oily antiseptic called creosote to protect them from insect bites. (Courtesy of Boynton Beach Historical Society.)

MANGO TREES AND PINEAPPLES, 1902. Pioneers planted mango seeds in tin cans filled with soil, producing new trees. The grove steadily expanded for the growers. (Courtesy of Boynton Beach Historical Society.)

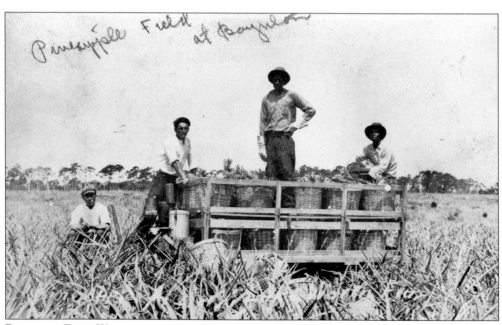

Pineapple Field at Boynton

PINEAPPLE FIELD WORKERS, C. 1900. Cutters in the field had to wear protective gloves, boots, and canvas pants to protect themselves from the serrated spines on the pineapples' leaves. (Courtesy of Boynton Beach Historical Society.)

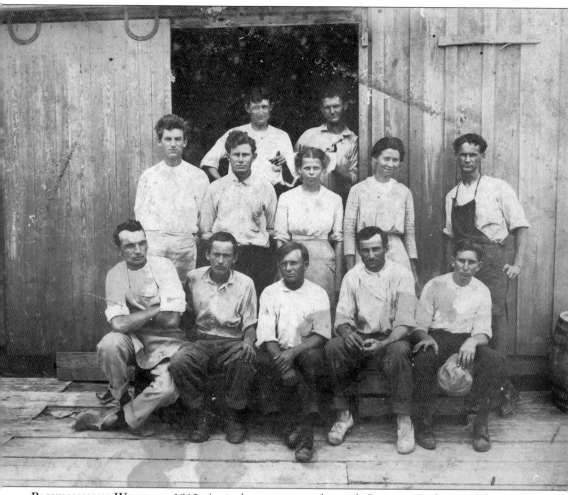

PACKINGHOUSE WORKERS, 1913. Agriculture was central to early Boynton. Packing and shipping became a booming business. For transportation, laborers walked or rode their bicycles to the packinghouse. Young men helped to make the crates, and the young ladies carefully wrapped the tomatoes in thin sheets of paper. Efficient workers made $5 a day for their efforts. It was tough work, but the packinghouse employees appreciated the social aspect of working together. (Courtesy of Boynton Beach Historical Society.)

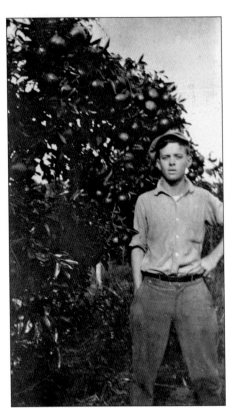

MANGO TREE, C. 1900. Charles Pierce stands by a fragrant mango tree. In early June, the large oval fruit with a thick oily peel turned a spectacular sunset red as it ripened. (Courtesy of Boynton Beach Historical Society.)

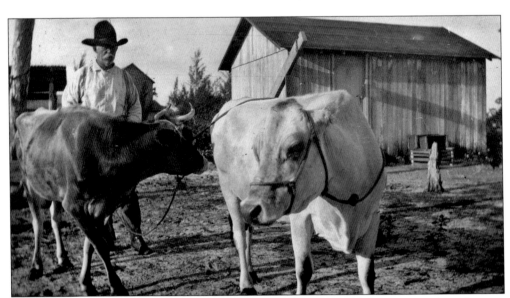

HARPER'S CATTLE, C. 1900. Cows cannot live on grass alone, but need the nutritional supplements provided by cow chow. Some early dairies were located near the ocean, a desirable place to keep the mosquitoes away from the cattle. (Courtesy of Boynton Beach Historical Society.)

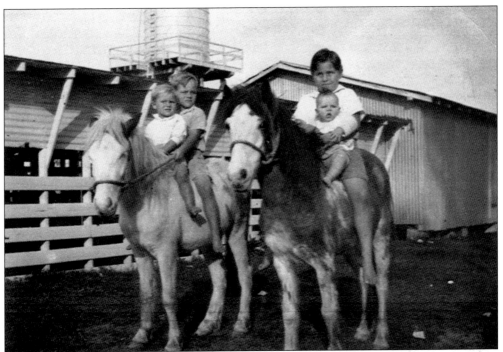

PONY RIDE, C. 1930. The Weaver brothers enjoyed riding their ponies around the farm while they were growing up. Pictured from left to right are Marcus, Curtis, Stanley, and baby Melvin. (Courtesy of the Weaver family.)

MILK TRUCK, C. 1950. In the early years, M. A. Weaver milked his cows by hand. As the dairy herd grew and milk production increased, he took the milk in a thousand-gallon tank truck to Southern Dairies Creamery in West Palm Beach. (Courtesy of Lois Argo Weaver.)

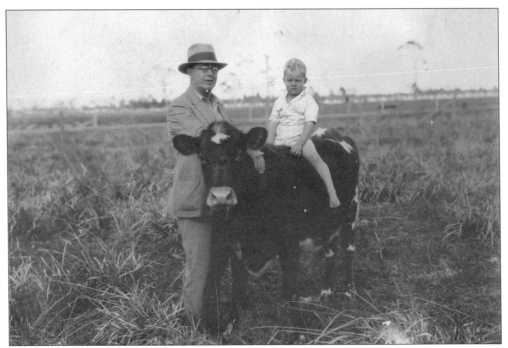

COW PASTURE, C. 1930. Little Marcus Weaver was introduced to the family business at an early age. Here he sits atop a young heifer alongside his father, M. A. Weaver. Marcus and his brothers later took over the dairy. (Courtesy of Lois Argo Weaver.)

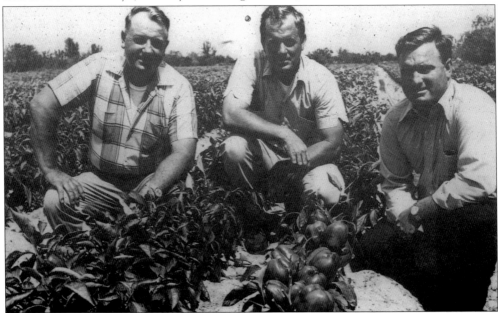

VEGETABLE FARMING, 1966. From left to right, William A. DuBois Sr., Billy DuBois, and Bobby DuBois check the green peppers in their field. The DuBois family began farming beans in Palm Beach County in 1933. DuBois Farms grew from 200 acres to 2,500 acres. At their peak, they employed 700 workers. Their vegetables have been shipped worldwide and sold in neighborhood markets. (Courtesy of Joan and Bobby DuBois.)

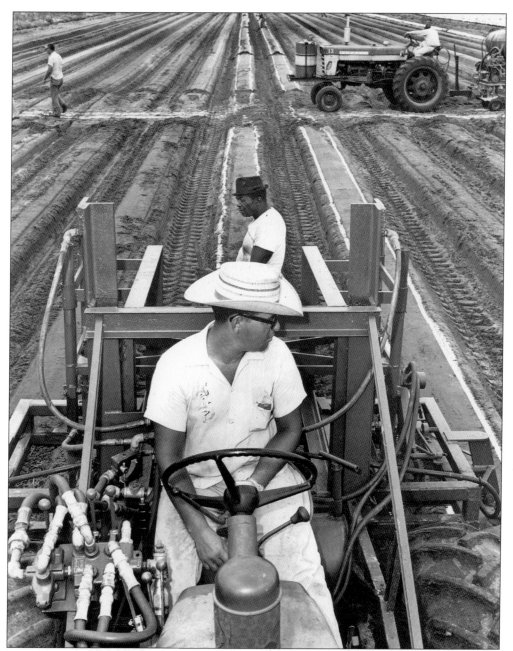

FERTILE FIELDS, C. 1960. Agriculture continued to flourish during the last century, even through droughts, pestilence, and hurricanes. After the 1928 storm, farmers said that they were discouraged with farming. As the sun's rays came out and the price of beans soared, they were back planting again. By the 1970s, residential growth and state regulations caused many farmers to give up their family farms and sell out to developers in Boynton Beach. (Courtesy of Boynton Beach City Library.)

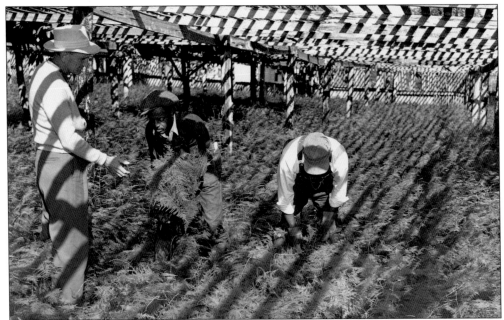

FERN GROWERS, 1951. Ferns growing in the shade were cut and shipped north for floral arrangements. From left to right are Fred Benson, John Harrington, and Golden Harvey. (Courtesy of Boynton Beach Historical Society.)

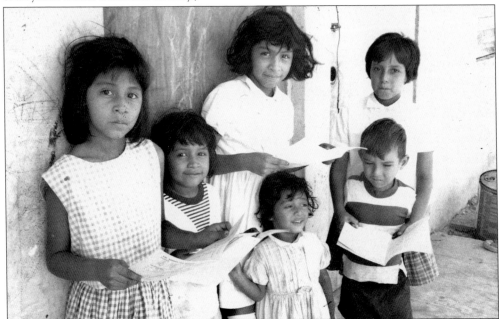

MIGRANT CHILDREN, 1960s. Farm workers migrated from region to region with the seasons, and often lived in housing provided by the landowner. The migrant children listened to school classes broadcast on WHRS broadcast from Hagen Ranch School radio. WHRS later became WXEL and is the public radio and television station located on Congress Avenue. Migrant families were provided with health and social services through the Caridad Clinic and the Community Caring Center. (Courtesy of Boynton Beach City Library.)

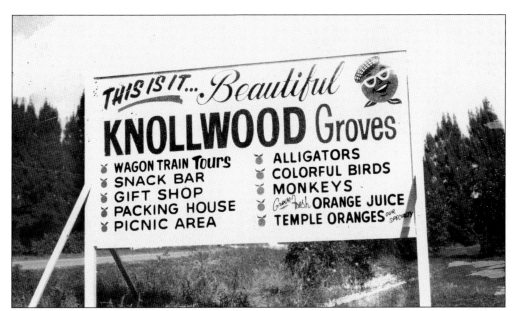

THIS IS IT, C. 1960. This sign welcomed visitors to Knollwood Groves, located on Lawrence Road. Orange juice stands used to be a common sight in the Boynton vicinity. (Courtesy of Boynton Beach City Library.)

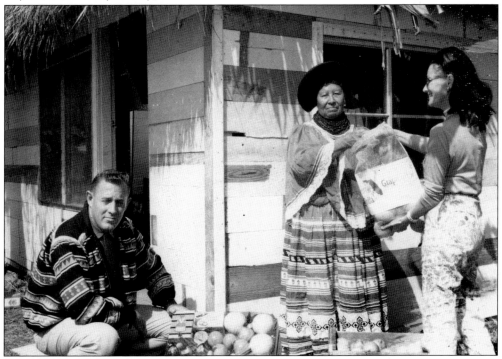

KNOLLWOOD GROVES, C. 1950. Knollwood Groves, one of many Boynton orange groves, began with 120 acres. A refreshing drink of freshly squeezed orange juice, a taste of homemade fudge, or the opportunity to bring home sacks of oranges, lemons, or fresh key lime pie made Knollwood a popular destination with tourists and locals. This last thriving grove in Boynton finally succumbed to development and closed in 2005. (Courtesy of Boynton Beach City Library.)

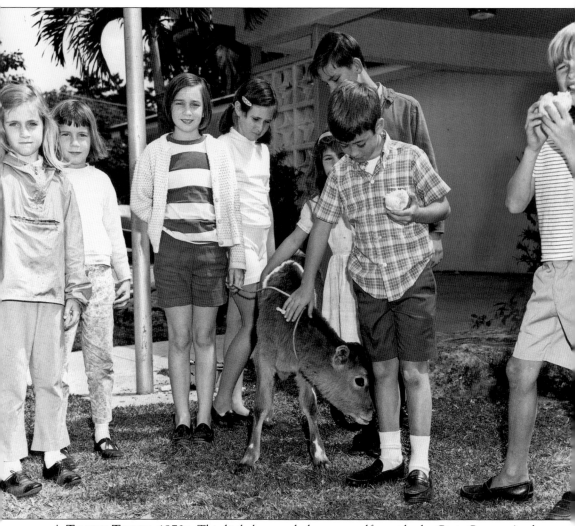

A TENDER TOUCH, 1970s. This little boy tenderly pets a calf outside the Civic Center. As the farms were replaced by housing tracts, animals were brought to children so they could learn about agriculture. Children today can still experience farm animals at the South Florida Fair, which is held each January in West Palm Beach. They can also learn about early farm life at Yesteryear Village in West Palm Beach and at the Schoolhouse Children's Museum in Boynton Beach. (Courtesy of Boynton Beach City Library.)

Six

THE SCHOOL BELL
IS RINGING
Education

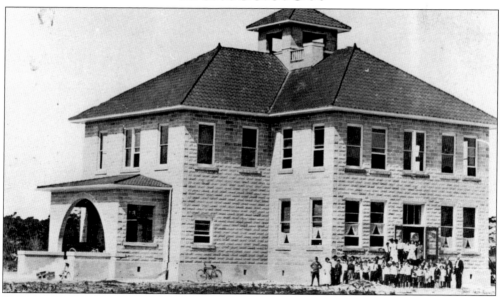

BOYNTON ELEMENTARY SCHOOL, 1913. The school, designed by West Palm Beach architect William Maughlin, opened on September 8, 1913, with 81 students. The two-story, six-classroom building was the pride of the community and housed all 12 grades. Although it had indoor plumbing, electricity did not arrive until the 1920s. The schoolhouse was the hub of activity for the community, a place of education and where neighbors and visitors gathered for local events. The building closed as a school in 1990, was restored in the mid-1990s, and is listed on the National Register of Historic Places. In November 2001, the Schoolhouse Children's Museum opened in the renovated building. The museum's mission is to encourage children and families in the area to learn about themselves and the history of Boynton Beach and Palm Beach County through a stimulating array of hands-on and interactive exhibitions, programs, activities, and special events. (Courtesy of Boynton Beach Historical Society.)

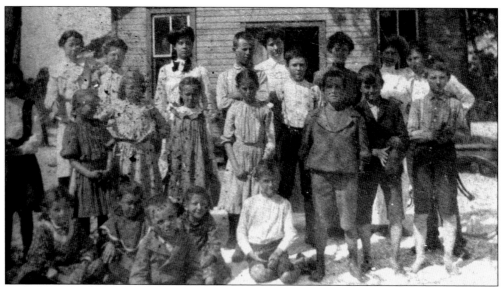

ONE-ROOM SCHOOLHOUSE, 1907. In 1900, townsfolk joined together to build the first permanent school to serve as a community center and church for local residents and for the construction workers temporarily living in the Boynton area. This one-room, wood-frame structure with gray clapboard siding and a shingle roof stood at what was then the western edge of town, bordering pinewoods and pineapple fields (now Seacrest Boulevard and Ocean Avenue). A school bell hung in the belfry called all the students from the first through the ninth grades to the single classroom. Miss Ruby Coates was the first teacher employed at the school. Mr. W. S. Shepard was the principal. (Courtesy of Boynton Beach Historical Society.)

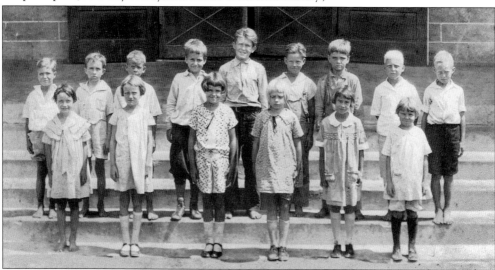

FIRST GRADE AT BOYNTON SCHOOL, 1920s. The eager young students at Boynton Elementary attempt to stand perfectly still on the porch outside the wide-screened doors of the two-story brick school. Some of the children are barefoot. If they owned a pair of shoes, the precious shoe leather was saved for Sunday wear only. The school's design, with many large windows and screened doors, was intended to let in the natural sunlight and the balmy ocean breeze. If the temperature dropped below 60 degrees, the students were sent home because the building had no heat. (Courtesy of Boynton Cultural Centre.)

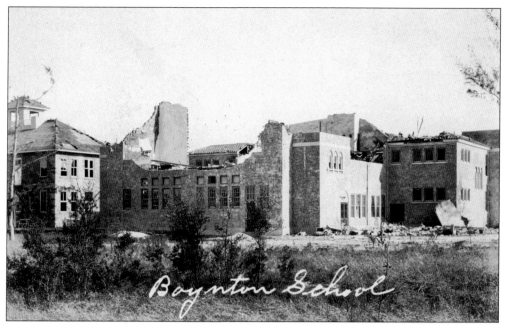

BOYNTON HIGH AFTER HURRICANE, 1928. School overcrowding became apparent in the 1920s. In 1926, a bond issue was passed to provide funds for another school in Boynton. The construction of the new two-story high school heralded the occasion of two schools operating side by side. The building was used as a shelter during the 1928 hurricane. During the storm, the second-floor auditorium collapsed. The school was rebuilt and continued to flourish. (Courtesy of Sheila Taylor.)

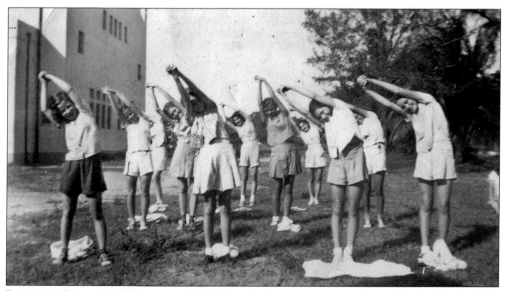

PHYSICAL EDUCATION CLASS, C. 1938. Even before yoga was popular in Florida, these young ladies enjoyed a good stretch. Outdoor exercise time was revered on pleasant days, when the youngsters donned their physical education clothing and escaped into fresh air. (Courtesy of Lois Weaver Argo.)

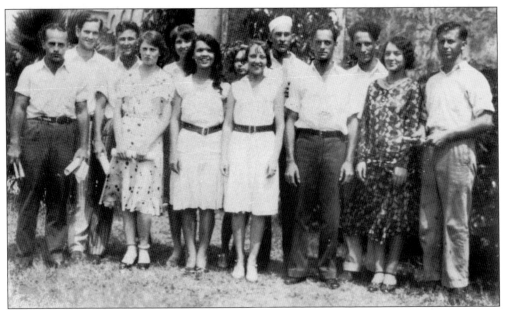

BOYNTON HIGH SCHOOL CLASS, 1931. One of the small early classes at the Boynton High School, these students, graduating during the depths of the nation's Great Depression, are still smiling. Pictured, from left to right, are the following: (first row) Bert White, Lucille Tuck, Helen Shepard, Ethel Powell, Roger Fain, Dorothy Powell, and Tommy J. Woolbright; (second row) Curtis Cherry, Otley Scott, Mabel Rousseau, Miriam Richardson, Charles Winegartner, and Lee Andrews. (Courtesy of Boynton Beach Historical Society.)

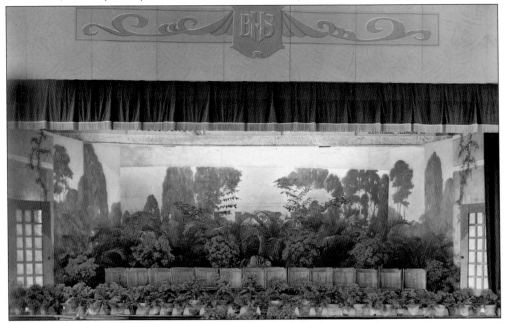

GRADUATION SETTING, 1939. The Boynton High School second-floor auditorium was transformed into a grandiose setting for the graduating class of 1939. Some of the courses the students could take at BHS were Spanish, home economics, agriculture, algebra, physics, and geometry. (Courtesy of Boynton Beach Historical Society.)

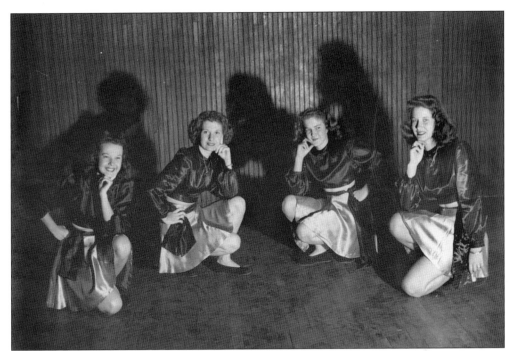

GLAMOUROUS CHEERLEADERS, 1948. Looking as attractive as the stars from a 1940s film, these lovely ladies strike a reflective pose. From left to right are Joann McCall, Charlotte Tatum, Mary Alice Dorow, and Mary Shook. (Courtesy of Boynton Cultural Centre.)

DRILL TEAM DANCER, C. 1942. Helen Senior, daughter of Charles Senior, Boynton's first fire chief and a leader in the community, stands peacefully in the shade of a coconut palm tree while the world around her is at war. (Courtesy of Boynton Cultural Centre.)

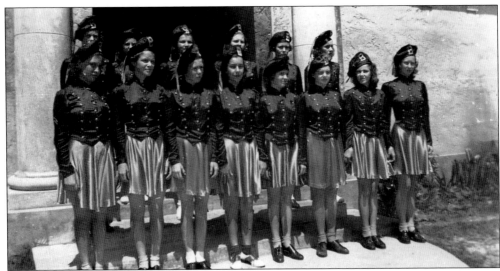

BOYNTON DRILL TEAM, 1940S. This precise drill team stands at attention in their brass-buttoned uniforms. The drill team performed dance routines at the school basketball games and special events. (Courtesy of Boynton Cultural Centre.)

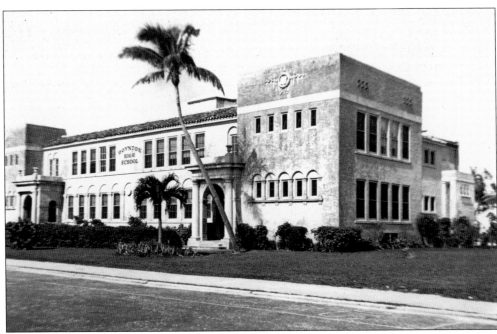

BOYNTON HIGH SCHOOL, 1940S. The last group of students graduated from Boynton High in 1949. A new high school opened a few miles south on Green Street (now Seacrest Boulevard) and was called Seacrest High, which was later renamed Atlantic High School. It would be another 50 years before Boynton had its own high school again. (Courtesy of Boynton Beach Historical Society.)

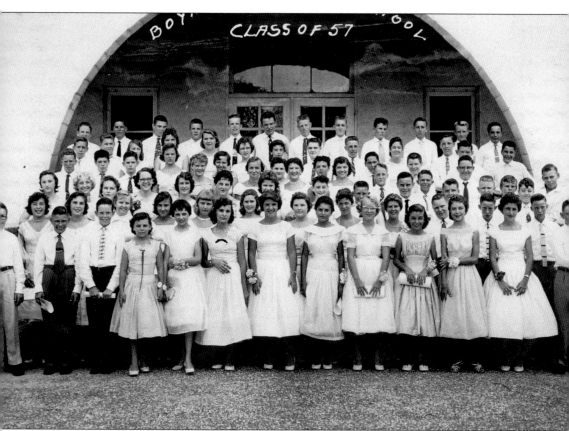

EIGHTH-GRADE CLASS, 1957. It was a great year for the 1957 Chevy, Elvis, and the class of 1957. Decked out in their finest attire, these junior high–school graduates celebrate. The girls even wore wrist corsages for this transitional occasion. (Courtesy of Boynton Cultural Centre.)

BLANCHE HEARST GIRTMAN, 1940s. A young Boynton teacher, Miss Blanche Hearst, taught African American second and sixth graders in this one-story, four-room school called Boynton Elementary. Built in 1925, this school was located north on Green Street (now Seacrest Boulevard) near the present Poinciana school. The name was changed to Poinciana because of the many Poinciana trees on the campus. Blanche Hearst Girtman's community and civic work are recognized on a permanent plaque in Pioneer Park. (Courtesy of Blanche Girtman.)

FIELD TRIP FUN, 1960s. Students on a field trip refresh themselves with cold Coca-Colas from ribbed bottles. The sweet soft drink with a straw was a treat. (Courtesy of Boynton Beach City Library.)

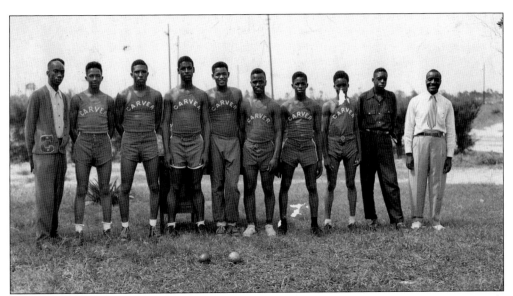

CARVER TRACK TEAM, 1948. These handsome students were star athletes at Carver High School in Delray Beach. The school was named after the famous African American educator and agricultural researcher George Washington Carver. In 1902, when scientist George Washington Carver asked for coconuts for experimental purposes, Henry Flagler arranged for his Palm Beach gardener to forward them immediately. The segregated student bodies of Seacrest High and Carver High were combined in the late 1960s to form one team. This strong union became Atlantic High School in 1972. (Courtesy of Cecil Adderley.)

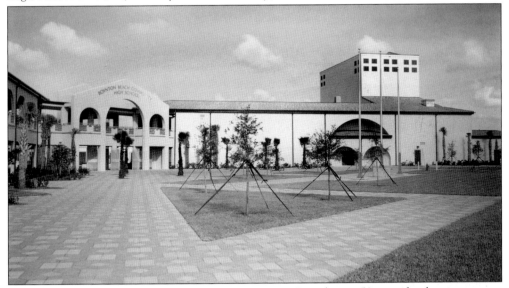

BOYNTON BEACH COMMUNITY HIGH SCHOOL, 2001. It took over 50 years for the city to once again have its own high school. During the last half of the 20th century, students traveled out of the city to attend one of three different high schools. The citizens lobbied for over a decade to unite our community, and the new Boynton Beach Community High School was dedicated in 2001. It was built to accommodate 2,500 students and has a performing arts academy. Its large theater, football stadium, and gymnasium all serve as gathering places and continue to foster community spirit. (Courtesy of Boynton Beach City Library.)

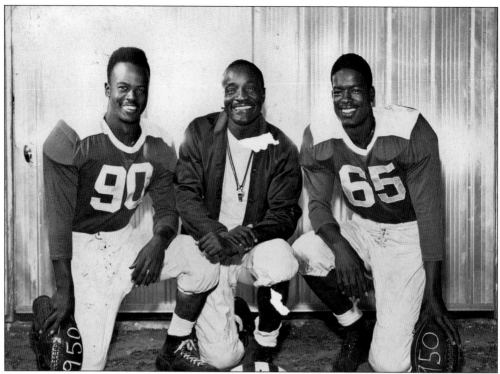

COACH AND MENTOR SPENCER POMPEY, 1950. Cecil Adderley (left) and Herman Pride (right) were encouraged to excel by following the positive example set by Spencer Pompey (center). (Courtesy of Cecil Adderley.)

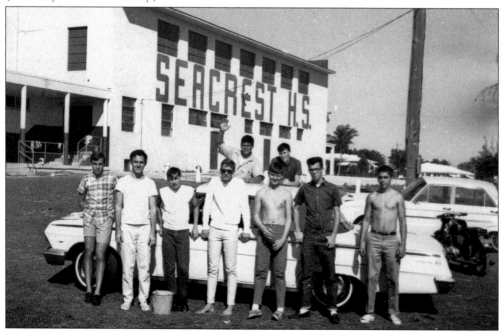

SEACREST HIGH CAR WASH, 1950s. Students bolster community spirit by fund-raising together at a Saturday carwash. (Courtesy of Boynton Beach Historical Society.)

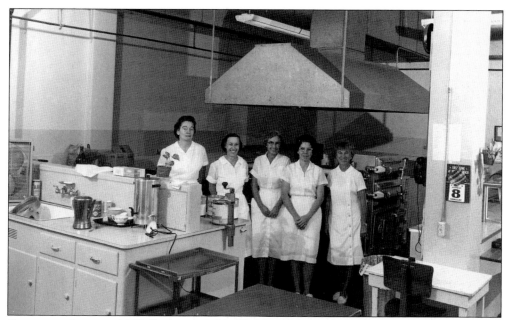

CAFETERIA LADIES, 1965. By the second half of the 20th century, Boynton Elementary School, originally built in 1927, had a full, modern kitchen. The cafeteria ladies served hot lunch to the burgeoning ranks of baby-boomer students. Remember the fish sticks, tater tots, and little cartons of milk? Even in February, the kitchen needed a fan to cool off the dedicated cafeteria workers. (Courtesy of Boynton Cultural Centre.)

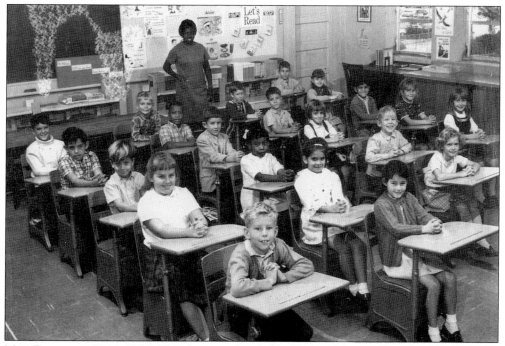

MISS RUTHANN IVEY, 1969. The classroom headed by Ruthann Ivey is all smiles. The longtime teacher promoted the love of reading and good books to her students. (Courtesy of Boynton Cultural Centre.)

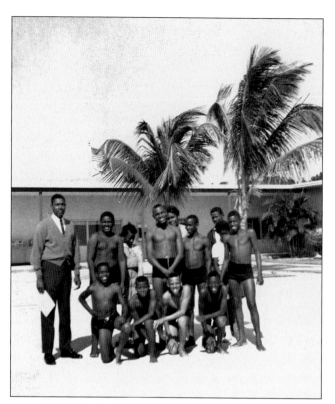

WILSON POOL, PARK AND CENTER, c. 1960. These swimmers are taking a break from swim practice at Wilson Pool. The Wilson Pool was built in 1956. It was planned and built at the request of Deacon Theodore D. Wilson, an advocate for recreation and parks. When the Civic Center was being planned, Wilson explained the need for a recreation center in the neighborhood off Green Street (now Seacrest Boulevard) north of Second Avenue (now Boynton Beach Boulevard). Wilson Center, Park, and Pool all bear this leader's name. (Courtesy of Boynton Beach City Library.)

EZELL HESTER, 1960s. A life-long Boynton resident, Ezell Hester was an educator and taught at area schools, including Congress Middle. In 1988, he became Boynton's first African American mayor. After his death in 1989, the city named a recreation center and park in his honor, known as the Hester Center. (Courtesy of Boynton Beach City Library.)

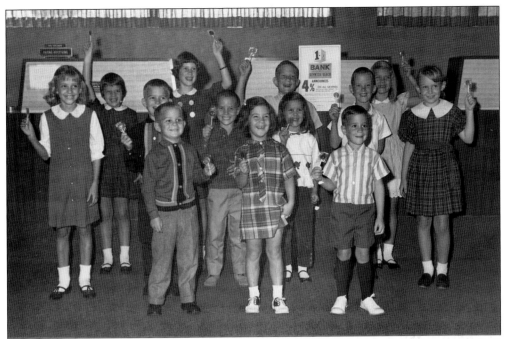

LOLLIPOPS KIDS, 1950S. Elementary children enjoyed visiting local places of business on field trips like this one to First Bank and Trust. The students enjoyed the short walk down Ocean Avenue for their educational trip. They were rewarded with cherry lollipops at the end of the visit. (Courtesy of Boynton Cultural Centre.)

A HEAD START IN LIFE, 1990S. For over 40 years, Lena Rahming has served as a community leader and the director of the Boynton Beach Head Start Program. The thousands of local children served by this program reap the benefits of educational and social skills that will prepare them for the future. Those with this head start in life are often self-starters and enrich our community. (Courtesy of Boynton Beach Child Care Center.)

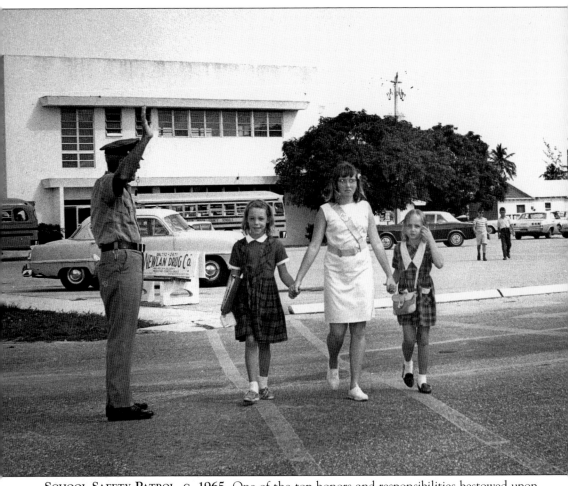

SCHOOL SAFETY PATROL, C. 1965. One of the top honors and responsibilities bestowed upon civic-minded sixth graders at Boynton Elementary was becoming a member of school safety patrol. Valerie Lacey valiantly escorts two children across Seacrest Boulevard while crossing guard Mr. Kendel holds the traffic at bay. (Courtesy of Boynton Beach City Library.)

Seven

EVERYONE LOVES
A PARADE
Celebrations

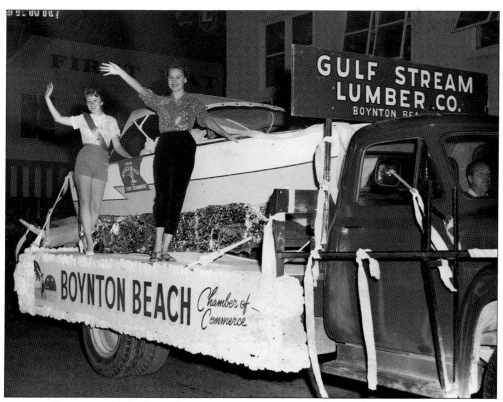

SAILFISH PARADE, 1950S. In 1950s small-town Boynton Beach, people found numerous ways to keep life from becoming too placid. Each holiday was celebrated with a church or school pageant and capped off with a festive parade. (Courtesy of Boynton Beach City Library.)

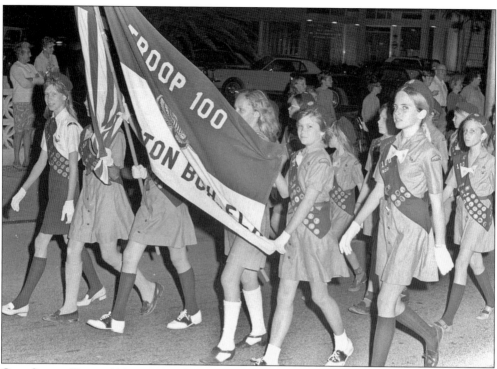

GIRL SCOUT TROOP 100, 1960s. This scout troop leads the way in the parade, marching swiftly along with their troop flag. (Courtesy of Boynton Beach City Library.)

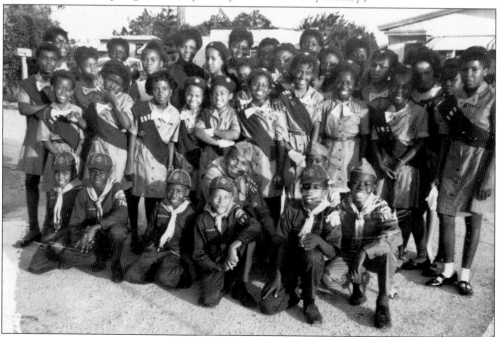

SMILING SCOUTS, 1960s. These young scouts and their leaders enjoyed getting together for group activities. They learned skills and received merit badges. (Courtesy of Boynton Beach City Library.)

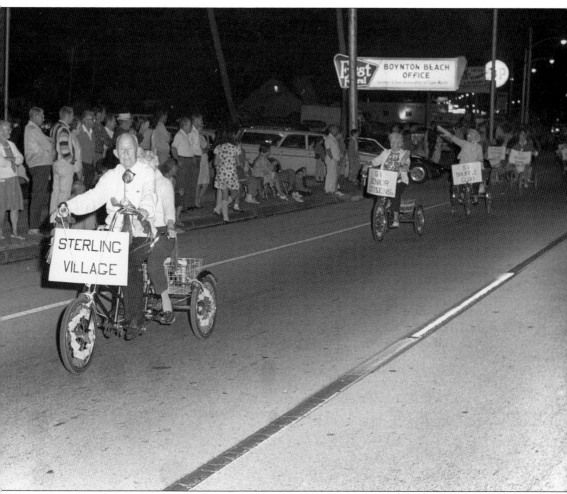

STERLING VILLAGE, 1970s. Senior citizens pedal their way down the parade route with their bikes festively adorned with red, white, and blue crepe paper. (Courtesy of Boynton Beach City Library.)

WATCHING THE PARADE GO BY, 1960S. The Boynton Beach holiday parade is an annual tradition for many families. Federal Highway closes to traffic and crowds line the street. (Courtesy of Boynton Beach City Library.)

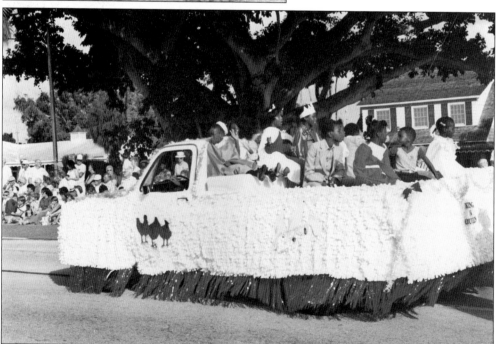

LITTLE KING AND QUEEN, 1970S. In this photograph, children eagerly wave to friends from the floats that family members helped to decorate. (Courtesy of Boynton Beach City Library.)

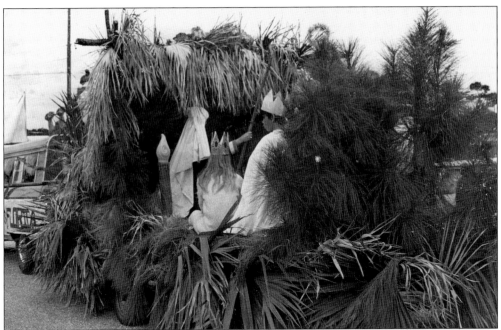

CHURCH FLOAT, 1960s. Using natural fauna and palm branches, this church group is shown creatively decorating their Christmas float. Palm branches and flowers from the area have been used by residents as decorations for celebrations throughout the century. (Courtesy of Boynton Beach City Library.)

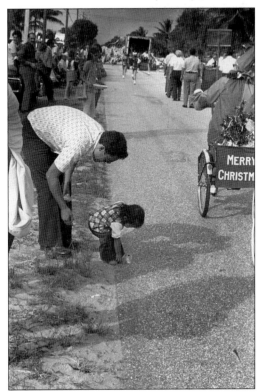

GOODIES FOR THE KIDDIES, 1960s. A little girl picks up a piece of candy that has been tossed her way along the parade route. (Courtesy of Boynton Beach City Library.)

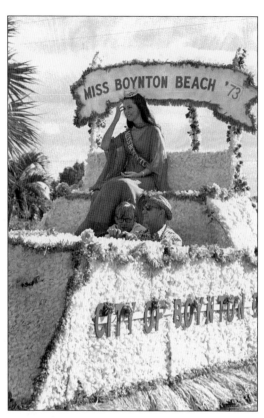

MISS BOYNTON BEACH, 1973. As seen in this picture, charming Miss Boynton Beach rides atop the City of Boynton Beach float. The Boynton Beach Junior Women's Club sponsored the Miss Boynton Beach Pageant, an official preliminary to the Miss Florida and Miss America pageants. Starting in 1965 and continuing into the 1970s, this annual springtime event celebrated the All-American girls of Boynton. During the four-day Miss Boynton Beach Festival, most of the town turned out for a gala parade. A local civic club sponsored each contestant, and the parade featured bands, marching units, floats, civic club entries, clowns, and special guests. (Courtesy of Boynton Beach City Library.)

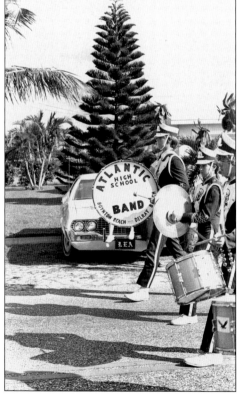

STRIKE UP THE BAND, 1970. The Atlantic High School band is composed of young people from Boynton Beach and Delray Beach. Participation in extracurricular activities has created well-rounded students with a love for music. (Courtesy of Boynton Beach City Library.)

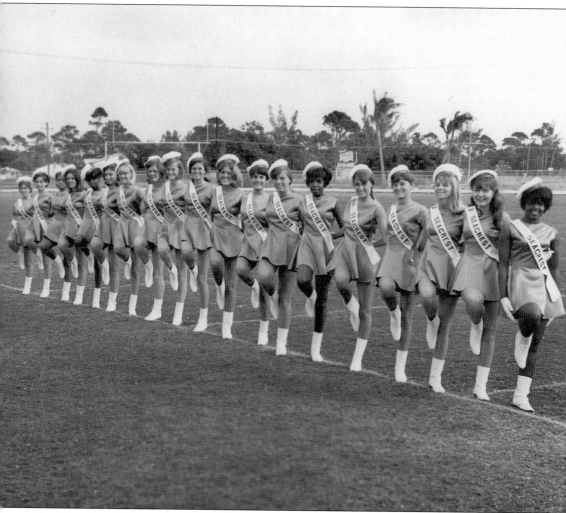

THE SEACREST HAWKETTES, 1967. The original Hawkettes, a precision march and dance team, performed in parades and at football games. These girls will always remember the hot and heavy satin green uniforms and capes. Memories include the red lipstick, the constant reminder to get their kicks up, and praying that they would be in front of the horses in the parade. (Courtesy of Penni Greenly.)

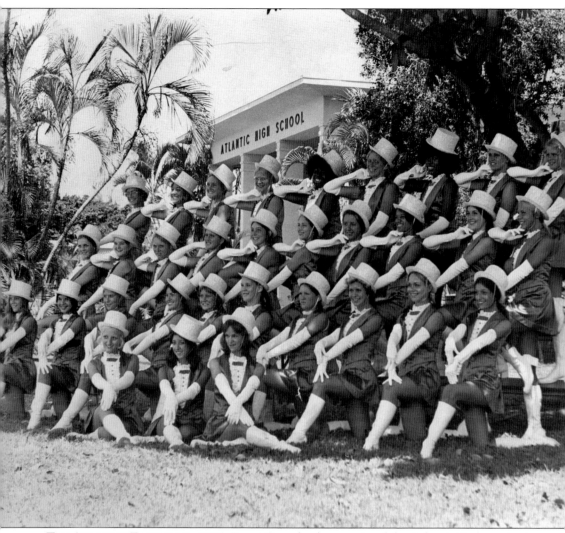

THE ATLANTIC EAGLETTES, 1975. Penni Greenly, the captain of the Atlantic Eaglettes in the 1970s (pictured in the bottom row, right), founded Southern Dance Theatre in Boynton Beach. For over 20 years, she has been active in supporting the arts and in encouraging young people to give back to the community. (Courtesy of Penni Greenly.)

Eight

LET THE GAMES BEGIN
Sports and Recreation

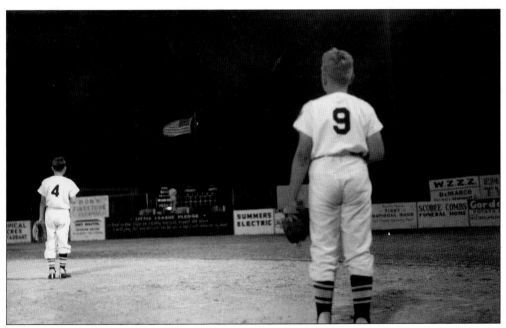

THE BOYS OF SUMMER, 1960s. A Boynton Beach Little League team stands at attention for the singing of "The Star Spangled Banner." (Courtesy of Boynton Beach City Library.)

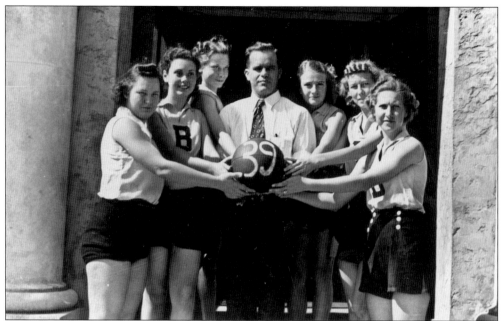

GIRLS BASKETBALL TEAM, 1939. Boynton High School sported a state-of-the-art combined gymnasium and auditorium on the second floor, known as the "gymnatorium." Coach Swilley trained both the boys' and the girls' basketball teams. From left to right are Bernice Traylor, Catherine Foy, Virginia Jones, Coach Swilley, Jackie Partin, Lorraine Lewerenz, and Helen Adams. (Courtesy of Boynton Cultural Centre.)

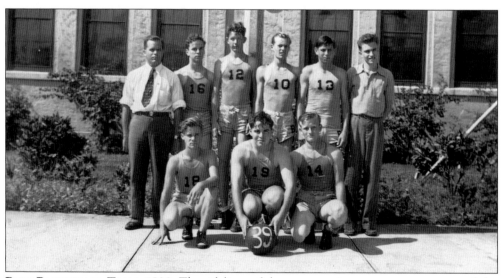

BOYS BASKETBALL TEAM, 1939. The sidelines of the gymnatorium were very narrow, and the basketball hoops had to be set up when practice or games occurred. From left to right are the following: (first row) Carl Brant, Stanley Weaver, and Louis Culpepper; (second row) Coach Swilley, Clyde Brown, Bob White, Dick Pierce, Herb Schultz, and Marvin Benson. (Courtesy of Boynton Beach Historical Society.)

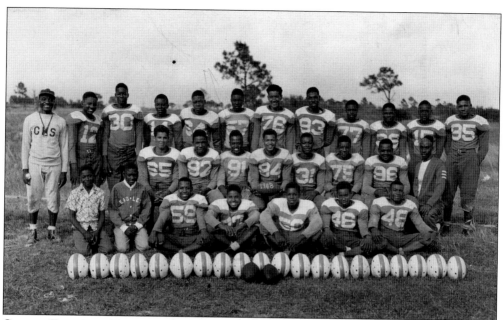

CARVER FOOTBALL TEAM, 1948. Spencer Pompey wore many hats as principal, teacher, and coach at Carver High School. (Courtesy of Cecil Adderley.)

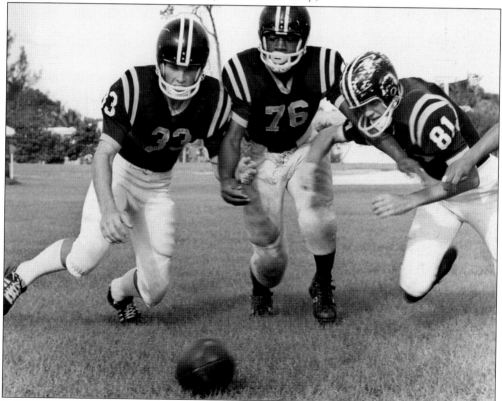

FOOTBALL SCRIMMAGE, 1970s. The Atlantic High School Eagles, guided by Coach Carney Wilder, were in four state championships during the 1970s. (Courtesy of Boynton Beach City Library.)

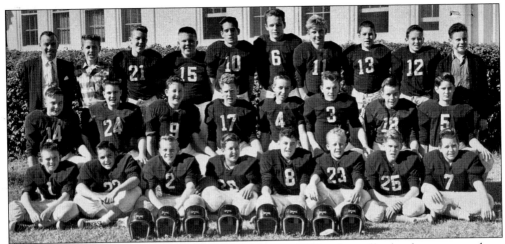

BOYNTON JUNIOR HIGH SCHOOL FOOTBALL TEAM, 1950s. A small school gave many boys who wanted to play football the opportunity to participate on the school team. (Courtesy of Lynn Grace.)

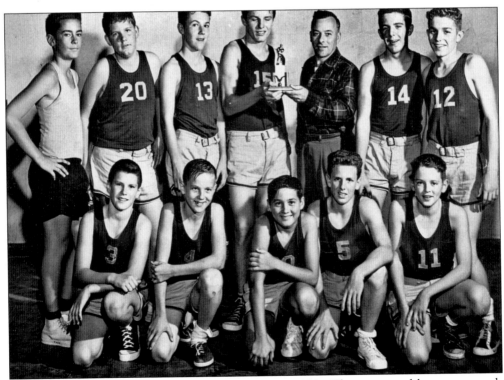

BOYNTON JUNIOR HIGH SCHOOL BASKETBALL TEAM, 1950s. These young athletes won awards based on their teamwork and sportsmanship. (Courtesy of Lynn Grace.)

SHUFFLEBOARD TOURNAMENT, 1960s. Since the 1930s, the city of Boynton Beach has had a shuffleboard court. This game, played year-round in south Florida, requires skill. Often those who are older are victorious over the younger players. (Courtesy of Boynton Beach City Library.)

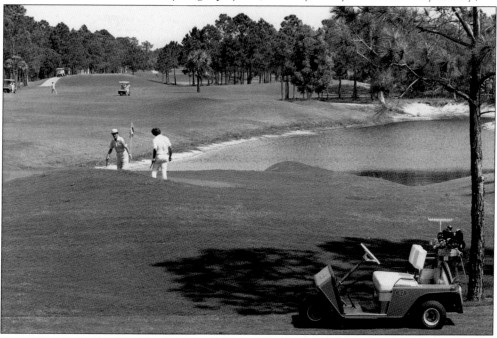

QUAIL RIDGE GOLF COURSE, 1980s. Golf is a popular sport in Boynton Beach, where many beautiful golf courses abound. Some of the other fine courses are Cypress Creek, Delray Dunes, Hunters Run, Leisureville, The Links at Boynton Beach, Pine Tree, and Village of Golf. The golf courses are used for recreation, competition, and charitable endeavors. (Courtesy of Boynton Beach City Library.)

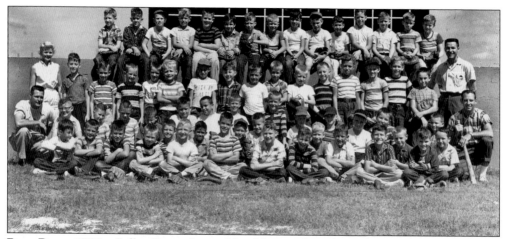

PLAY BALL, 1960s. Cullen Pence donated land for a park in the early 1920s so the boys could play ball. The city named the field Pence Park in his honor. (Courtesy of Boynton Beach Historical Society.)

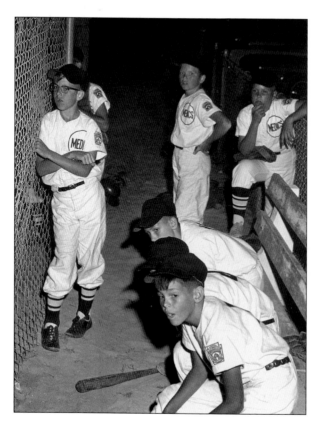

PUT ME IN, COACH, 1960s. In this photograph the boys in the dugout intensely follow the game. They were members of the Medics Little League baseball team. (Courtesy of Boynton Beach City Library.)

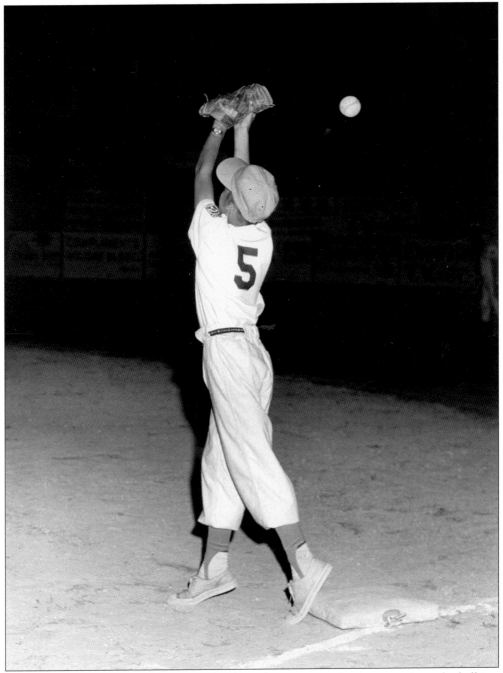

POP FLY, 1960s. Every player dreams of making that winning play, but sometimes the ball just slips off your glove. It is always important to remember that tomorrow is a whole new ballgame. (Courtesy of Boynton Beach City Library.)

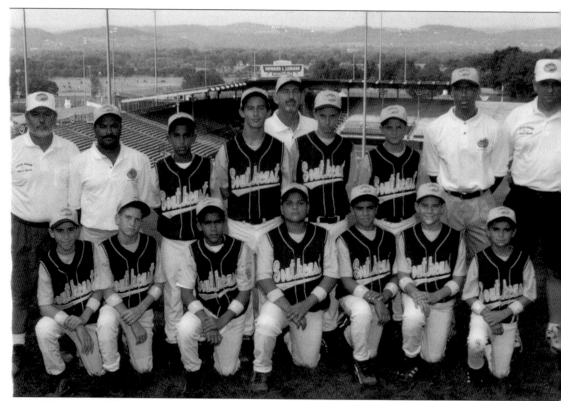

NATIONAL CHAMPIONS, 2003. At the Little League World Series held in South Williamsport, Pennsylvania, August 15–24, 2003, the East Boynton Beach team won the national championship. The city had a parade for the team and the Florida State Legislature, mayor, and commissioners recognized them for their spectacular accomplishment. Pictured in this photograph, from left to right, are the following: (first row) Patrick Mullen, Matt Overton, Devon Travis, Richie DeJesus, Jordan Irene, Andrew Weaver, and Ricky Sabatino; (second row) team uncle Heff, Joe Irene (coach), R. J. Neal, Michael Broad, Ken Emerson (manager), Cody Emerson, Benny Townend, Tony Travis (coach), and team uncle Chuck. (Courtesy of City of Boynton Beach.)

Nine

Gateway to the Gulf Stream
Civic and Social

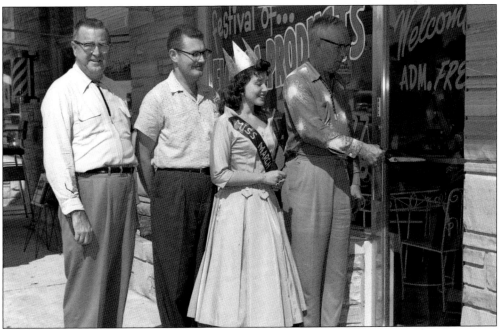

Business is Booming, 1958. At this point in history, the quiet suburbia in the downtown area was changing from mango groves to modest houses around Ocean Avenue and Seacrest Boulevard. Boynton Beach, a city with virtually no traditional "community history" before the coming of Flagler's railroad, had transformed itself over the first half of the 20th century. Early residents watched as street names changed and new businesses appeared. Shown here at the ribbon cutting of the Festival of Florida Products are, from left to right, Martin Durkin (vice-mayor), Harvey E. Oyer Jr. (commissioner), Sherry Lou Kinch (Miss Boynton Beach for March), and L. S. Chadwell (mayor). (Courtesy of Boynton Beach City Library.)

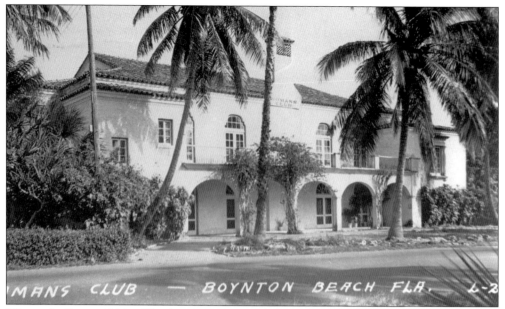

WOMAN'S CLUB, 1930S. The first Woman's Club building on Ocean Avenue was built with lumber salvaged from the shipwreck *Coquimbo*, which had floundered off Boynton in 1909. The ladies kept a lending library and held dances, bake sales, fish fries, community dinners, and beauty contests. In 1924, the women wanted a larger building to be used for club activities and a community center with a larger library. Major Boynton's heirs contributed $35,000 toward the new clubhouse as a memorial to their father. (Courtesy of Boynton Beach City Library.)

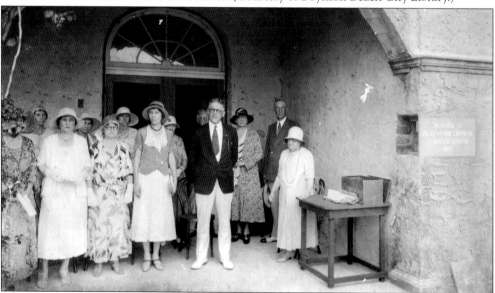

WOMAN'S CLUB DEDICATION, 1932. The cornerstone to the Woman's Club was laid on April 16, 1932, and the building and property were dedicated to the memory of Maj. Nathan Smith Boynton. Throughout the years, dances, meetings, socials, and theater presentations have been held at the clubhouse. Church groups and other societies met at the building until they could have their own facilities. During World War II, the Red Cross and the USO used it as a center. (Courtesy of Boynton Beach Historical Society.)

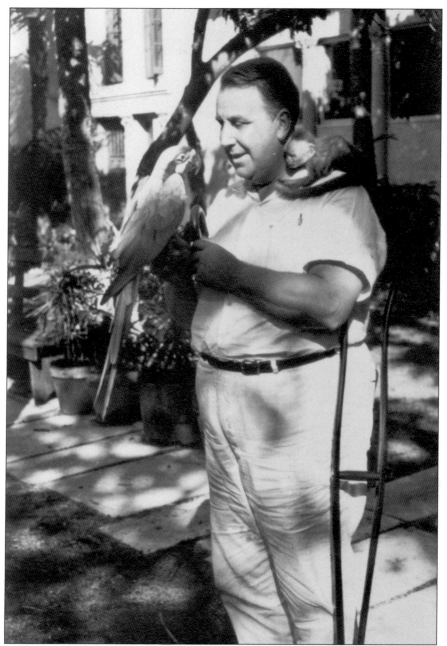

ADDISON MIZNER, 1930. World-famous architect Addison Mizner designed the new Woman's Club. Mizner, of Palm Beach and New York, had plans for building a hotel in Boynton. At the urging of his personal friend and Boynton resident Bertha Chadwell, and as a gesture of goodwill among townspeople, Mizner agreed to design and supervise the building of the clubhouse. This landmark has overall elegance and character reflective of the creativity and genius of Mizner. The Woman's Club is on the National Register of Historic Places. Mizner would walk around with his beloved spider monkey, named Johnny Brown, perched on his shoulder as he worked on his creations. Sometimes he would dress Johnny up in a silk-lined sombrero. (Courtesy of Historical Society of Palm Beach County.)

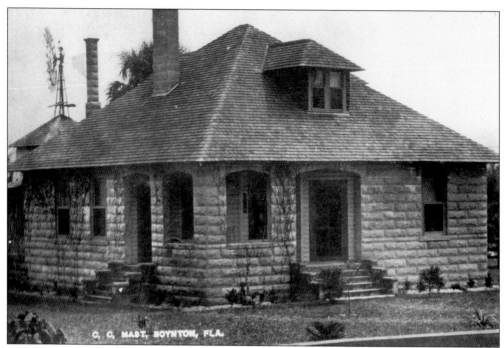

First Concrete Block House, 1907. C. C. Mast built this early home. The house, made of concrete block, was the first in Boynton designed to withstand hurricane-force winds. (Courtesy of Boynton Beach Historical Society.)

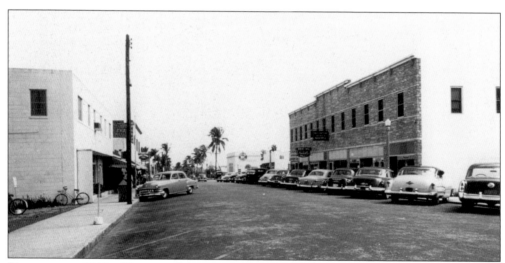

Downtown, 1940s. This view shows Ocean Avenue at it looked in the 1940s. The impressive two-story building on the right was erected in 1913 and housed the Bank of Boynton. According to some accounts, this building was constructed with rails from the Celestial Railroad. In 1919, Mr. T. A. Newlan, a pharmacist, opened the first drug store in town on the first floor. Harold's Barber Shop also shared the first floor with the bank. The Jones Hotel was on the second floor and operated from 1924 to 1938. (Courtesy of Boynton Beach Historical Society.)

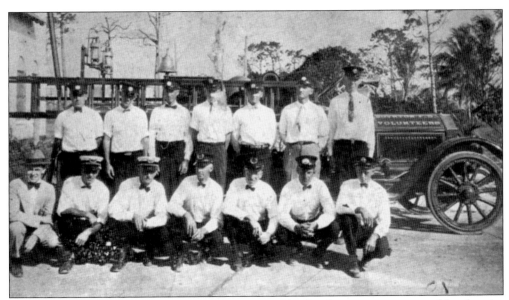

VOLUNTEER FIRE DEPARTMENT, 1925. In 1924, Charles Senior was appointed by the city commission to organize a fire department and to serve as chief. The volunteer department started with a two-wheel cart and 500 feet of fire hose. The hose had to be light in order to get it on the cart. In 1925, the American LaFrance pumper seen above was bought by the firefighters themselves. It was known as *No. 1*. Pictured here, from left to right, are the following: (first row) William P. Sommerville, Chief Charles Senior, Wally Hughes, John B. Meredith, F. "Red" Jourick, Arthur R. Cook, and Ewing Porter; (second row) Ed Lombard, Sam Cox, T. A. Ward, F. Durrance, Bobby Hodges, Fred Benson, and William Weems. (Courtesy of Boynton Beach City Library.)

MEREDITH'S ELECTRIC SHOP, 1925. John Meredith installed the first electric lights in Boynton in 1921, helping the town move into the modern era. Meredith and his family lived upstairs in the first Woman's Club building on Ocean Avenue. A curtain that separated them from the club meetings afforded them some privacy. (Courtesy of Boynton Beach Historical Society.)

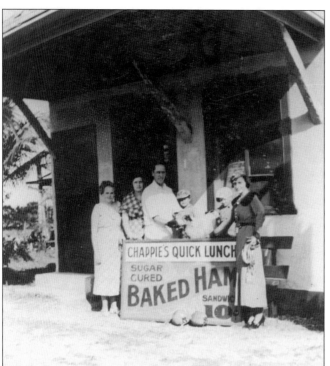

CHAPPIE'S QUICK LUNCH, 1935. Fast food was offered at Chappie's, where a baked ham sandwich was advertised for 10¢. The smell of smoked ham, fresh baked bread, and mustard was unforgettable. There was a butter spread made from what locals called "the alligator pear," which was an avocado. (Courtesy of Boynton Beach Historical Society.)

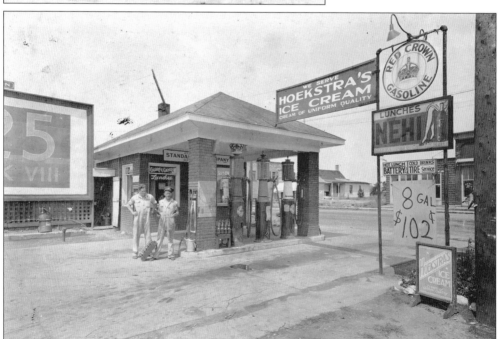

THE FILLING STATION, 1920S. A fill-up of gasoline, from a hand-operated pump with a glass-domed top, cost about 15¢ a gallon in the 1920s. People in Boynton took to driving automobiles like alligators took to swimming in canals. By the Roaring Twenties, the automobile was becoming a way of life for Americans. Henry Ford created an installment plan in which a Model T Runabout could be bought for $5 a week, at a total cost of $290. (Courtesy of Boynton Beach Historical Society.)

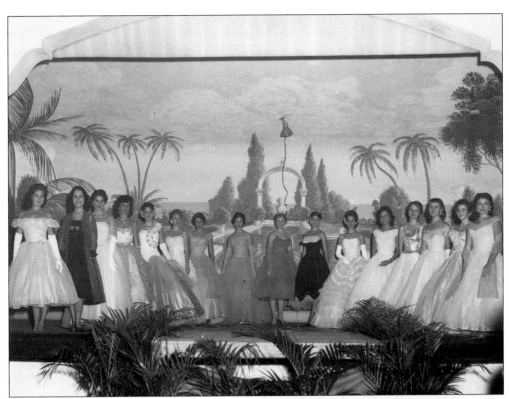

BEAUTY PAGEANT, 1950s. Beauty pageants provided young women the thrill of competition and a fun social activity. In this image, sparkling women shine with personality on the palm-laden stage at the Boynton Woman's Club. (Courtesy of Boynton Beach City Library.)

RAINBOW TROPICAL GARDENS, 1950s. Rainbow Tropical Gardens was on land bought in 1919 by Mr. and Mrs. C. O. Miller. They worked for years creating the gardens that were called "an artist's paradise." Today it is the site of Benvenuto's Restaurant. (Courtesy of Boynton Cultural Centre.)

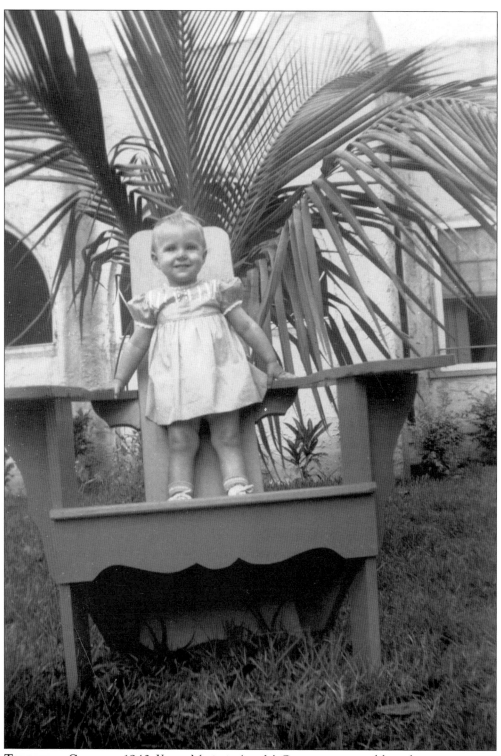

TODDLER IN CHAIR, C. 1940. Young Marjorie Ann McGregor grins impishly as she tries out a new Adirondack-style chair crafted by neighbor Ray Wilcox. (Courtesy of Boynton Cultural Centre.)

DOWNTOWN BOYNTON, 1940S. Looking west on Ocean Avenue from U. S. Highway 1, this intersection view, with a sailor leaning on a lamppost, resembles a Hollywood sound stage. (Courtesy of Boynton Beach Historical Society.)

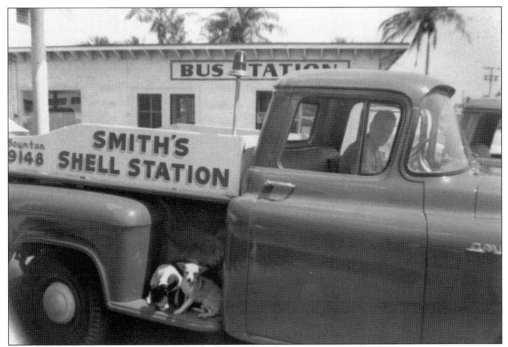

SMITH SHELL SERVICE STATION, 1956. Jim Smith, owner of the Shell Oil Company station, is shown sitting in his truck with his dog Jigger on the running board. Mr. Smith owned and operated three Boynton Beach auto service centers from the 1950s to the 1970s. (Courtesy of Boynton Cultural Centre.)

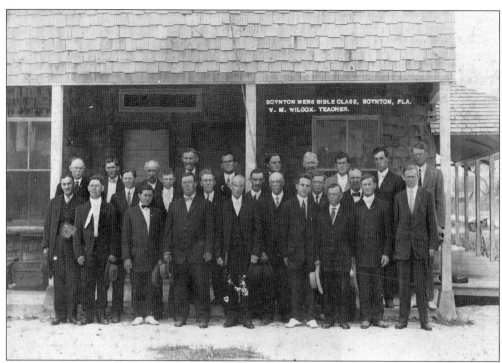

MEN'S BIBLE CLASS, 1914. Methodist men met regularly with their teacher, V. M. Wilcox, to study the Bible together. Religion played a large role in the lives of the early settlers, and they were faithful to their beliefs. (Courtesy of Boynton Cultural Centre.)

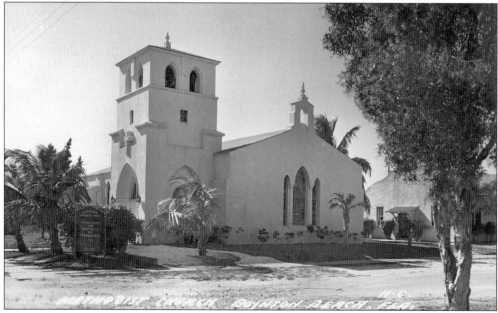

FIRST METHODIST CHURCH, C. 1950. The oldest house of worship in Boynton was organized in 1905. Early pioneers found great comfort and refuge in God's sanctuary. The cornerstone for the present building, shown here, was laid in 1949. The name was changed to First United Methodist in the late 1960s. (Courtesy of Boynton Beach City Library.)

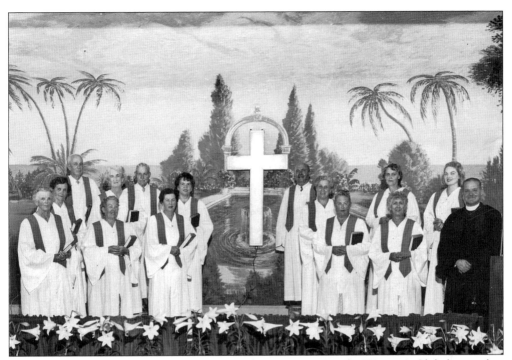

EASTER AT THE WOMAN'S CLUB, 1956. Presbyterians met at the Woman's Club for worship services in the early days of their congregation. The Woman's Club was host to many early church groups when they were getting started. (Courtesy of Boynton Beach City Library.)

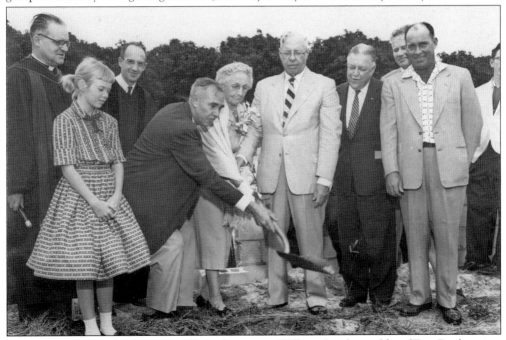

GROUNDBREAKING CEREMONY, 1959. In this image, William Smith, an elder of First Presbyterian Church, uses a spade to turn the sandy soil in a former mango grove for the groundbreaking of the new church. (Courtesy of Boynton Beach Historical Society.)

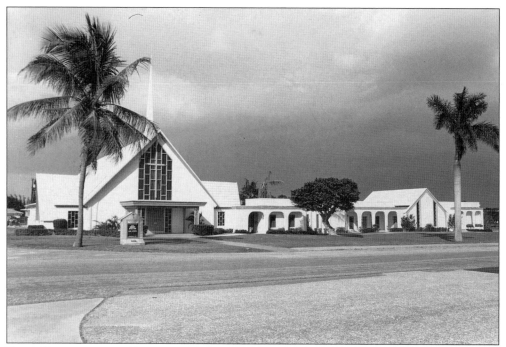

FIRST PRESBYTERIAN CHURCH, 1970S. The sanctuary of First Presbyterian Church has a ceiling design that symbolically resembles the wooden hull of a ship. (Courtesy of Boynton Beach City Library.)

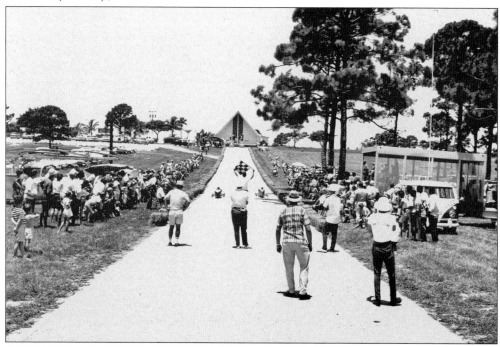

SAINT JOSEPH'S EPISCOPAL CHURCH, 1960S. This church, located high upon a hill, has a long driveway, which was an excellent place to hold the Soap Box Derby race. (Courtesy of Boynton Beach City Library.)

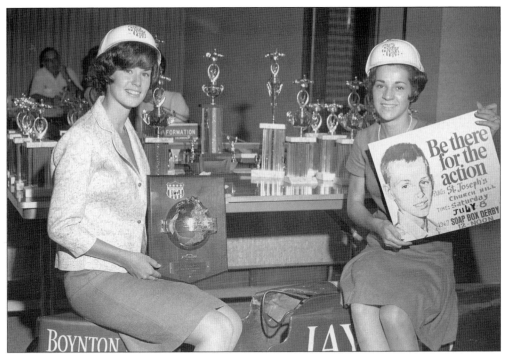

SOAP BOX DERBY, C. 1967. The annual Soap Box Derby was a community effort. The event brought participants, sponsors, families, and spectators closer together. (Courtesy of Boynton Beach City Library.)

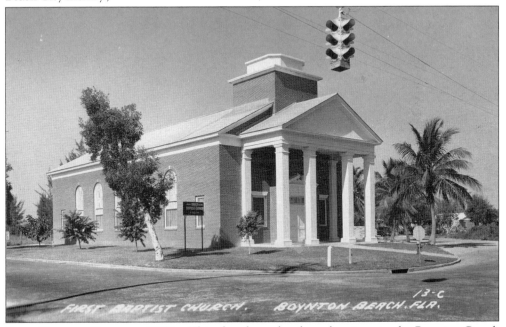

FIRST BAPTIST CHURCH, 1950S. This church used to have baptisms in the Boynton Canal, when the water was clean. Older boys would tell younger ones that crabs would bite their feet if they were baptized in the canal. In 2005, the sanctuary was expanded and an education center was built. (Courtesy of Boynton Beach City Library.)

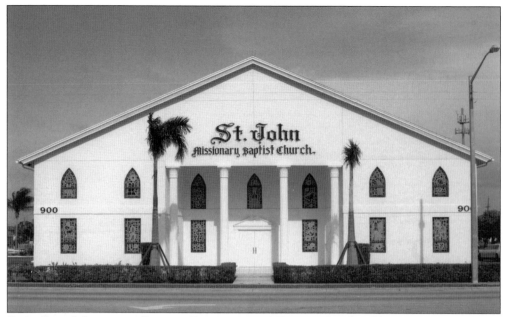

SAINT JOHN MISSIONARY BAPTIST CHURCH, 2005. Boynton Beach's oldest continuing African American congregation was founded in 1908. The Reverend Randolph Lee served as pastor for over 40 years and was a highly respected community leader. (Courtesy of Gregg Seider.)

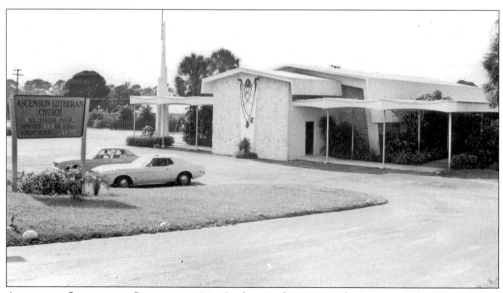

ASCENSION LUTHERAN CHURCH, 1970s. Lutherans first met in the Boynton Theater and then the Boynton Woman's Club. Shown here is the first section of their church to have a contemporary design. (Courtesy of Boynton Beach City Library.)

SAINT MARK'S CATHOLIC CHURCH, 1950s. The first mass for the Catholic Church in Boynton was celebrated in the local theater building in 1952. In 1953, property was acquired on the east side of Federal Highway, near the Intracoastal Waterway. The church and school are next to Mangrove Park. The church was enlarged and completely renovated and rededicated in 2004. (Courtesy of Boynton Beach City Library.)

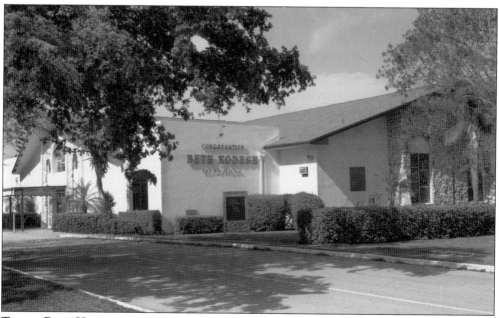

TEMPLE BETH KODESH, 2005. On April 13, 1976, Temple Beth Kodesh was officially organized as the first Jewish synagogue in Boynton Beach. Members met in the Boynton Beach Congregational Church until the construction of the synagogue in 1983. (Courtesy of Gregg Seider.)

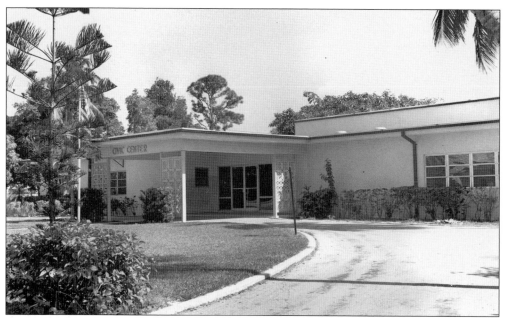

CIVIC CENTER, 1960s. The Civic Center is host to many groups and activities. The Cast-Off Square Dance Club gathers there, and the James E. Buffan Gold Coast Band performs concerts. Dance, music, language, craft, Jazzercize, and bridge classes are also conducted. The center is also a home for teen programs, which provide activities for area youth. (Courtesy of Boynton Beach City Library.)

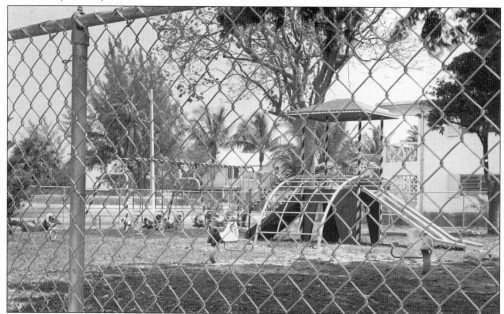

THROUGH THE FENCE, 1960s. These monkey bars, gliding horses, and slippery slide next to the Civic Center provided exercise, play, and happy days for neighborhood children. A new multi-level playground, called Kids Kingdom, was built next door to the Schoolhouse Children's Museum in 1996 by the city through the volunteer efforts of children, adults, businesses, and community groups. (Courtesy of Boynton Beach City Library.)

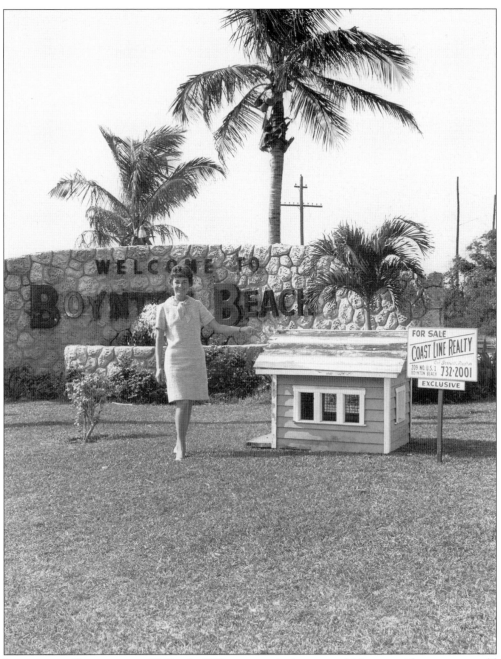

LOCATION IS EVERYTHING, 1960S. In 1959, new two-bedroom model homes with a carport could be purchased for $9,995. A new three-bedroom home with closed garage and Florida room was $16,900. The population in Boynton Beach has continued to climb, as shown by these census figures—1900: 83; 1930: 1,053; 1960: 10,467; 1980: 35,624; 2005: 65,000. (Courtesy of Boynton Beach City Library.)

WOODY IN CARPORT, 1953. The Woody station wagon was the ultra-dependable workhorse of families, camps, and businesses in the middle of the 20th century, and a precursor to the minivan and SUV. While life has changed around the Woody Wagon, those who love nostalgia and ocean sports have kept its heritage alive. The Woody-look is now synonymous with the surfer generation, who would strap their boards on the roof. (Courtesy of Boynton Cultural Centre.)

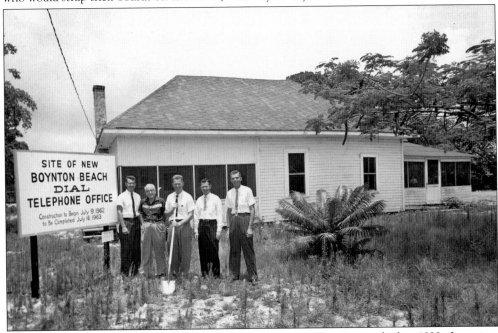

TELEPHONE IS RINGING, 1962. Telephones started to appear in Boynton in the late 1920s. Longtime city resident Jim Warnke was the city's only telephone repairman in 1956, and he took care of 2,500 customers using two-, four-, and eight-party lines. In 1963, a new central office opened to handle the growing demand for service. (Courtesy of Boynton Beach City Library.)

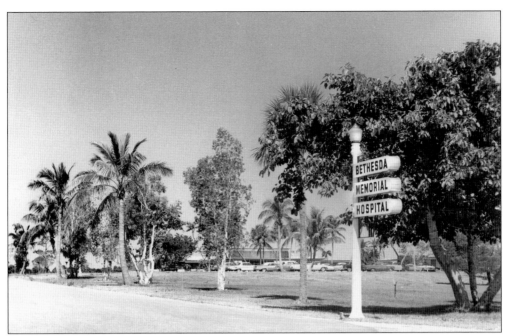

BETHESDA MEMORIAL HOSPITAL, 1959. On February 9, 1959, Bethesda Memorial Hospital opened its doors to the Boynton Beach community. Bethesda was the first hospital in south Palm Beach County, and there were 32 doctors and 65 employees. In the beginning, it was a 63-bed hospital. (Courtesy of Boynton Beach City Library.)

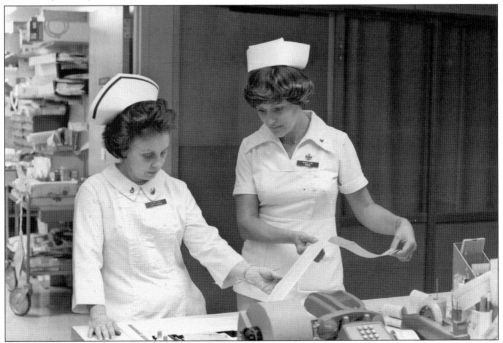

BETHESDA NURSES, C. 1960. By the end of the first year of operation, plans were being made to expand for the hospital's future. Bethesda has continued to grow over the years to meet the healthcare needs of the community. (Courtesy of Boynton Beach City Library.)

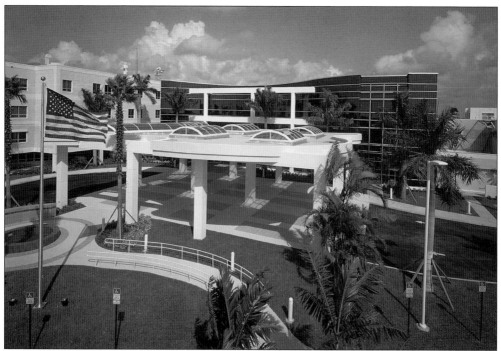

BETHESDA IN A NEW CENTURY, 2005. Bethesda Memorial Hospital, a top-rated hospital in the nation, has more than 500 physicians in more than 40 areas of specialty. Bethesda is one of Boynton Beach's largest employers, with more than 2,100 employees. (Courtesy of Bethesda Memorial Hospital.)

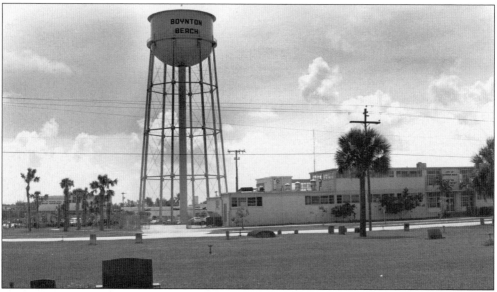

WATER TOWER, 1960s. Boynton Beach has always been known for the high quality of its drinking water. In 1930, Boynton merchants and citizens sponsored a handbill advertisement praising the glories of this water: "Boynton has the best water to be found in the state of Florida, without taint of sulphur or palmetto roots. Like the air here, it is so pure that it could be bottled and sold in less fortunate districts." (Courtesy of Boynton Beach City Library.)

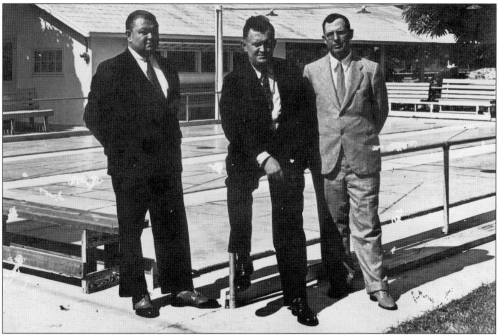

Doc Weems, 1930s. Dr. N. Marion Weems Sr. settled in Boynton in 1925 and became Boynton's first medical doctor. At that time, the town had a population of about 1,500 people. During the 45 years he practiced medicine, it is estimated he delivered 7,500 babies. Doc Weems never refused a patient, even if they could not pay, and agreed to barter with folks in exchange for his services. Doc Weems (center), who was also vice-mayor of Boynton, is seen here with town clerk A. V. Peterson (left) and Mayor M. A. Weaver (right). (Courtesy of the Weems family.)

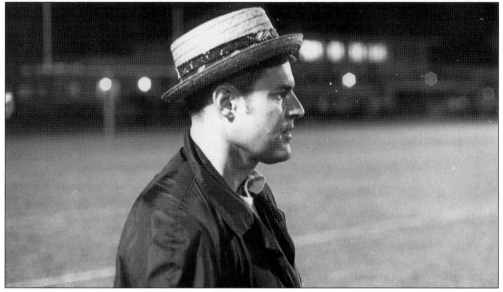

Dr. James Pollock, c. 1960. James Pollock was Boynton Beach's first orthopedic surgeon. For many years, he served as the team doctor for the Seacrest and Atlantic High School football teams. Watching over the players on the field, Dr. Pollock was present during the games to take care of any of the players who might become injured. (Courtesy of Elise Shankle.)

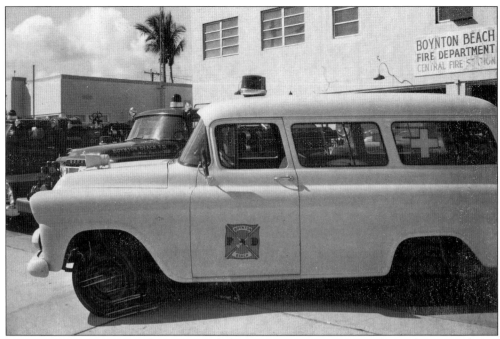

AMBULANCE, C. 1950. In the 1950s, ambulances were not very roomy for medics to work, but these rescue workers still saved lives. (Courtesy of Boynton Beach City Library.)

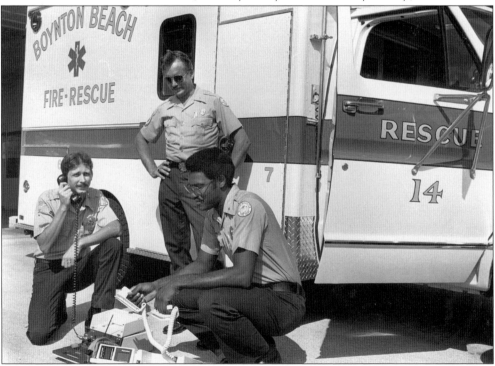

EMERGENCY 911, 1970S. Members of the Boynton fire rescue squad use the first telemetry equipment, capable of transmitting voice and electrocardiograms to local hospitals. (Courtesy of Boynton Beach City Library.)

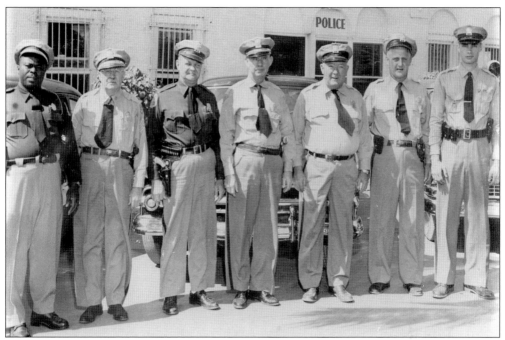

BOYNTON POLICE OFFICERS, 1950S. Police officers stand in front of the police building on N.E. Fourth Street, which today is the Animal Care and Control Center. In the 1950s, Boynton was a small town, almost free from crime. The officers were proud of their sponsorship of a Little League baseball team. Shown in this photograph, from left to right, are James Butler, Greatham Hodges Sr., Jules Klinger, Chief A. C. "Boots" Carver, John Collins, Jack Henderson, and James Erwin. (Courtesy of Boynton Beach Police Department.)

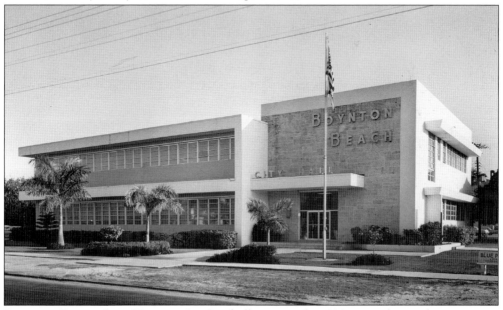

BOYNTON BEACH CITY HALL, 1958. City hall contained 14,000 square feet, and citizens were pleased that it was built without incurring any indebtedness. During the late 1980s, it was expanded and remodeled. (Courtesy of Boynton Beach City Library.)

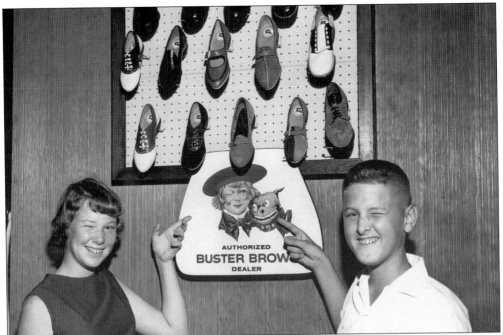

BUSTER BROWN, 1960S. The cherished Buster Brown line of shoes has been in business for over 100 years and was sold at Vince Canning Shoes in Sunshine Square. The winking boy with his sidekick pooch, Tige, made his way into comic books, radio, theater spots, and the newspaper. (Courtesy of Boynton Beach City Library.)

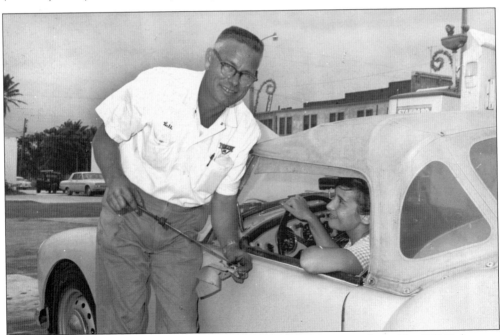

SERVICE WITH A SMILE, 1960S. In the 1960s, service station attendants like Bill Culpepper would fill your gas tank, check your oil, and clean your windows. In addition, the station would give you S&H green stamps to redeem for gifts. (Courtesy of Boynton Cultural Centre.)

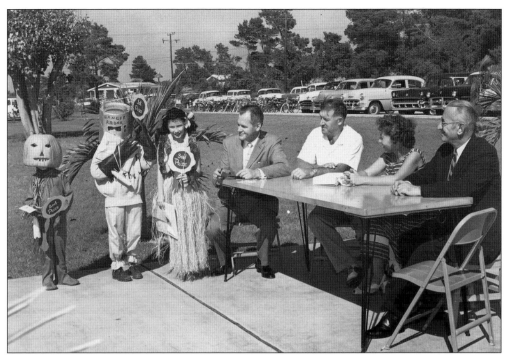

ALL DRESSED UP, 1960s. Winning costumes featured the Great Pumpkin, Radar Ranger, and Hawaiian Princess. Famed artist and muralist Bernard Thomas (second from left) served as judge for this event at Forest Park School. (Courtesy of Boynton Cultural Centre.)

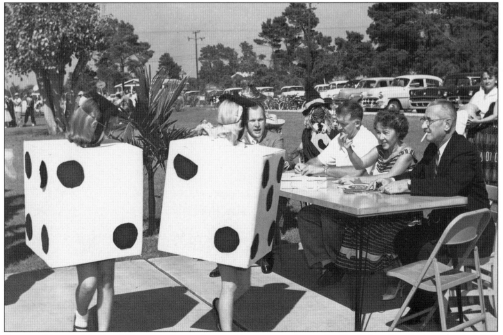

SNAKE EYES, 1960s. These girls work together on a clever "roll of the dice" costume in this picture. The long row of bicycles in the background shows that children continued to ride their bicycles to school, just like in pioneer days. (Courtesy of Boynton Cultural Centre.)

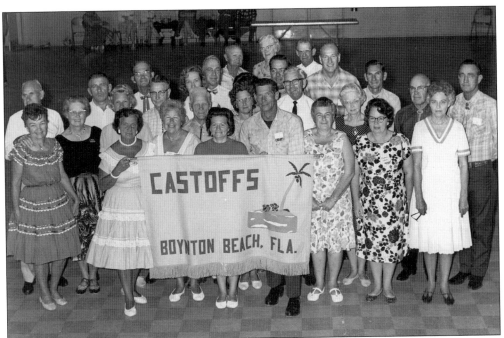

CASTOFF SQUARE DANCERS, 1960S. Swing your partner! Shown here in their beginning days, the Castoffs continue to have a fabulous time square dancing and socializing together at the Civic Center. (Courtesy of Boynton Beach City Library.)

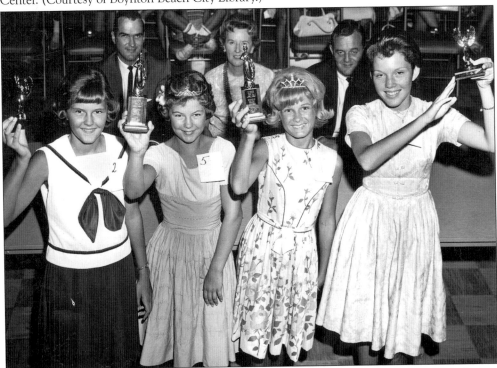

AWARDS PRESENTATION, 1960S. Some of the most cheerful girls in Boynton present trophies to the winners of the Soap Box Derby. (Courtesy of Boynton Beach City Library.)

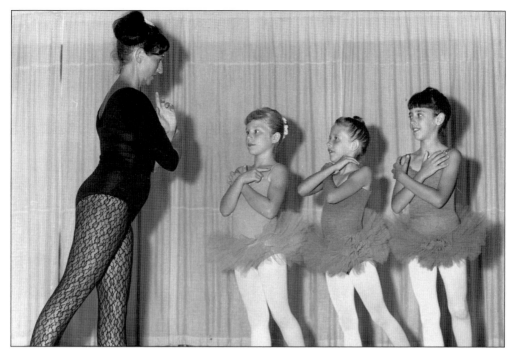

MISS GILLIAN, 1950S. A dance instructor in Boynton Beach for over 50 years, Miss Gillian has inspired thousands of local children. As Miss Gillian gives pointers to her ballet students, her husband accompanies the dancers on the piano. (Courtesy of Boynton Beach City Library.)

THE DANCER'S EDGE COMPANY, C. 2000. Southern Dance Theatre's "The Dancer's Edge" was founded in 1983 by Penni Greenly and Joan Miller. The company has performed at many events and festivals. They have also appeared at the Super Bowl half-time show, the opening of the 1988 Olympics, and at Universal Studios and Disney World. (Courtesy of Gregg Seider.)

SHOW ME THE MONEY, 1960s. Junior high–school students spend the day learning about finance and banking at First Bank of Boynton Beach. (Courtesy of Boynton Beach City Library.)

MERKEL BROTHERS' ORCHIDS, 1960s. The sweet smell of orchids grown in Boynton Beach can be attributed to brothers Jean (left) and Norman Merkel (right). These top horticulturists were deeply rooted in their community, and shared their passion for flowers and vast knowledge of agriculture with visitors, friends, and neighbors. Jean Merkel created over 10,000 hybrid orchids in 65 years. (Courtesy of Boynton Beach City Library.)

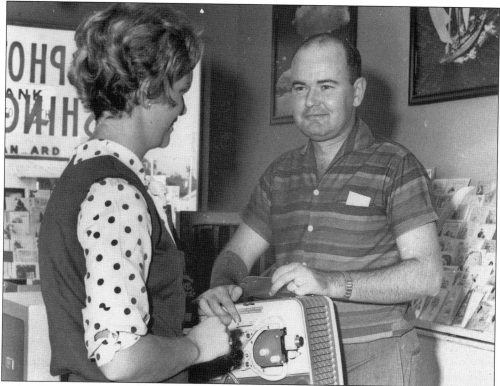

JACK'S CAMERA SHOP, 1960s. At Jack's Camera Shop in Sunshine Square, owned and operated by Jack Hirth, cameras, film, and movie projectors were for sale. Home movies documented family vacations and birthday parties. (Courtesy of Boynton Beach City Library.)

RACE CARS, 1960s. The Besecker brothers, Doug (left) and Dave (right), are thrilled to watch the toy cars zoom around this electric-powered track at Don's Firestone. (Courtesy of Boynton Beach City Library.)

CUT AND A SHAVE, 1950s. A sprinkle of talc would be brushed on the back of the neck, and a little dab of Brylcreem would hold hair in place. In the 1950s, shaves were $1. Walter Lacey, shown here, cut hair in Boynton for 45 years. Lacey's Barber Shop was a place to just "sit a spell" to talk and catch up on local news. (Boynton of Beach City Library.)

STEVEN'S DRUG STORE, 1960s. A spray of perfume on the wrist scented Steven's Drug Store with a sweet fragrance. Drug stores like this one used to have soda fountains and are mostly a thing of the past. Many teenage boys' first jobs were working as soda jerks at the local drugstore. (Courtesy of Boynton Beach City Library.)

LIBRARY DIRECTOR VIRGINIA FARACE, 1970S. Virginia K. Farace came to the Boynton Beach City Library as director in 1970. The library has played a monumental part in preserving and promoting local history. It is only fitting that the book Mrs. Farace is shown receiving on behalf of the library from John Howell, president of Boynton Beach State Bank, is titled *Pioneer Life In Southeast Florida*, written from the diaries and manuscripts of Charles W. Pierce. (Courtesy of Boynton Beach City Library.)

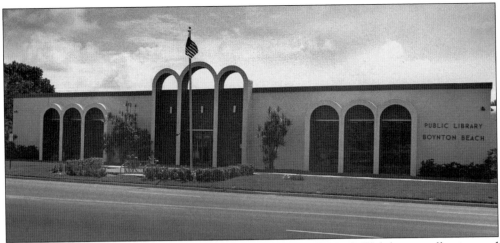

BOYNTON BEACH CITY LIBRARY, C. 1974. The Boynton Woman's Club began collecting and loaning books to the community in 1911, soon after it acquired its own building. Many of the book donations came from winter visitors who stayed at the old Boynton Hotel. In 1974, this modern library was dedicated. It was enlarged in 1991. With great community support, the Boynton Beach City Library will expand in 2006 to meet the growing needs of the population. (Courtesy of Boynton Beach City Library.)

HURRICANES FRANCES AND JEANNE, 2004. The library's large banyan tree was uprooted after battering by winds from Hurricane Frances on September 4, 2004. A few weeks later, Hurricane Jeanne followed. This is what happened to thousands of trees all over Florida. It was very unusual to get two almost identical hurricanes on back-to-back paths, and longtime residents said these were the worst storms since 1947. Neighbors rallied, joining together to help one another. (Courtesy of Boynton Beach City Library.)

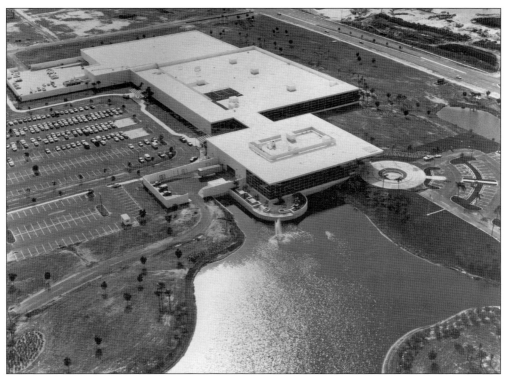

MOTOROLA, 1983. Motorola brought its pager division to Boynton Beach in 1977. A two-lane country road was widened to handle the increased flow of traffic created from Motorola and the new Boynton Beach Mall. The mall opened in 1985 on a former cow pasture. Motorola relocated in 2004, and the area is now a residential and shopping complex. (Courtesy of Boynton Beach City Library.)

LEISUREVILLE, 1960S. Retirees enjoy an active lifestyle of swimming and golfing during their golden years in Leisureville, one of Boynton Beach's many retirement communities. (Courtesy of Boynton Beach City Library.)

JIMMY BUFFETT, 1990s. Singer-songwriter and author Jimmy Buffett is shown with his beautiful custom surfboard at Nomad Surf Shop. (Courtesy of Ron Heavyside.)

NOMAD SURF SHOP, 2000. An institution with surfers and young people since 1968, Nomad Surf Shop is located a few miles south of Boynton Inlet. Custom-made surfboards, tropical bikinis, swim gear, and surf reports can be found there. (Courtesy of Gregg Seider.)

UNDER THE SHADE OF THE BANYAN TREE, 1970S. Boynton Beach today celebrates a colorful, multi-cultural heritage. Boynton is a sister city to Qufu, China, the birthplace and home of Confucius. The philosopher Confucius believed that welcoming friends from far away provided an opportunity to learn from one another. (Courtesy of Boynton Cultural Centre.)

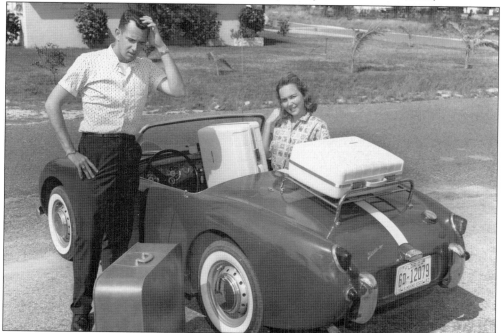

TOO MUCH STUFF, 1963. Everyone knows the feeling of packing too much for a trip. This Boynton couple could use a shoehorn and more trunk space in their sporty Austin Healey Sprite. (Courtesy of Boynton Beach City Library.)

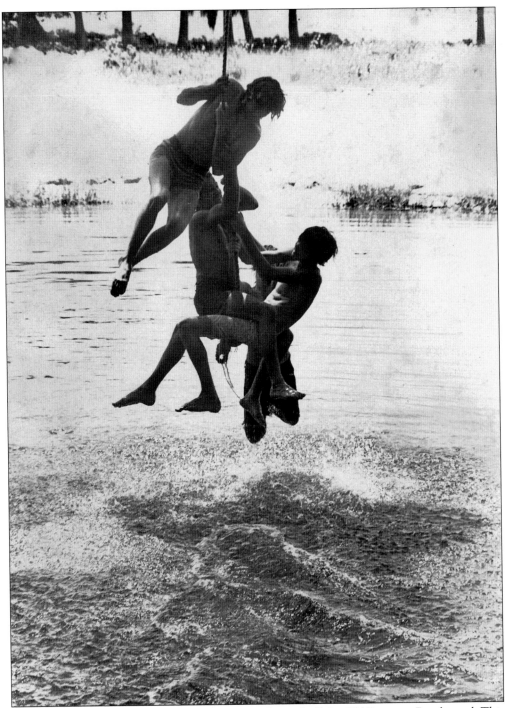

ROPE SWING, 1960s. Youth play on a rope swing located off the Old Boynton Road canal. This swing is a reminder that life is moving, like the pendulum of a clock. Memories flow deep within us, just as the indigo blue currents flow through the Gulf Stream. The memories created today and photographs we cherish become anchors in the sea of time. (Courtesy of Boynton Beach City Library.)